JOHN HEDGECOE'S COMPLETE GUIDE TO
Black & White Photography
and Darkroom Techniques

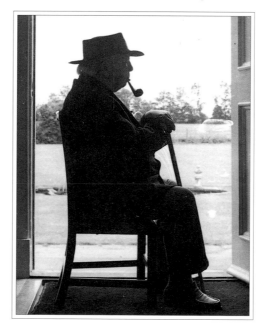

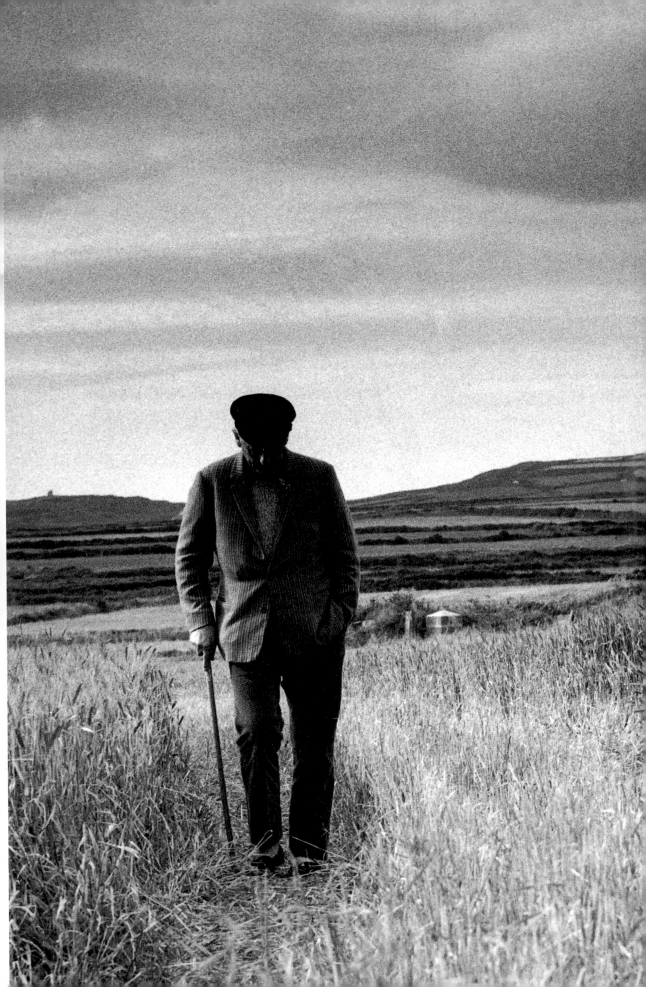

JOHN HEDGECOE'S
COMPLETE GUIDE TO
Black & White
Photography
and Darkroom Techniques

Sterling Publishing Co., Inc. New York

Published in 1994 by Sterling Publishing Company, Inc.
387 Park Avenue South, New York, N.Y. 10016
Originally published in Great Britain
by Collins & Brown Limited

Distributed in Canada by Sterling Publishing
c/o Canadian Manda Group, One Atlantic Group, Suite 105
Toronto, Ontario, Canada M6K 3E7

Library of Congress Cataloging-in-Publication Data
Hedgecoe, John.
 [Complete guide to black & white photography]
 John Hedgecoe's complete guide to black & white photography.
 p. cm.
 Includes index.
 ISBN 0-8069-0885-8
 1. Photography. I. Title: Complete guide to black and white
photography.
 TR146.H417 1994
 771--dc20 94-16839
 CIP

2 4 6 8 10 9 7 5 3 1

Conceived, edited and designed by Collins & Brown

MANAGING EDITOR: Sarah Hoggett
ASSOCIATE WRITERS: Jonathan Hilton and John Wade
ART DIRECTOR: Roger Bristow
DESIGNED BY: Phil Kay

Reproduction by Typongraph, Italy
Printed and bound in Great Britain

Sterling ISBN 0-8069-0885-8

Contents

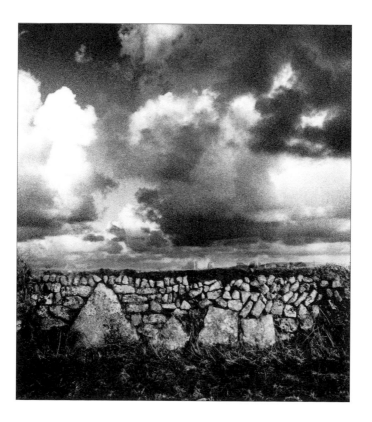

Introduction

WITHOUT DOUBT, black and white photography is a minority interest. Of all film sold worldwide, approximately 95 per cent is colour negative film stock. This leaves a mere 5 per cent of the market to be shared out between colour transparencies and black and white. Why then, if black and white is used by so few photographers, does the monochrome image have such an enduring appeal for its band of professional and amateur adherents?

Learning about photography

For those interested in learning about photography as a means of self-expression, interpretation or as a creative outlet, then the black and white medium has much to offer. This is not to say that precisely the same learning process is not possible with colour photography, and indeed the walls of exhibition halls and galleries regularly carry exciting, innovative and sometimes very moving images from colour photographers. However, by removing colour from the subject you immediately take your photographs one step back from the depiction of a simple likeness – they are at once divorced from the reality of the way we all see the world around us.

All photographs are an abstraction in one way or another. Even if the picture reveals a completely realistic and recognizable subject, it is only a two-dimensional representation of a three-dimensional scene consisting of a pattern of dyes on a piece of chemically treated paper a few millimetres thick. Taking away the colour as well as the dimension of depth furthers this process of abstraction, and thus encourages you to make something of that scene that is truly unique, something

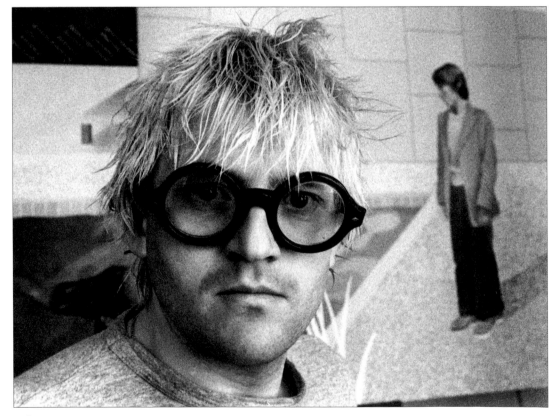

▲ SPATIAL AMBIGUITY
The simplification of this portrait of the English artist David Hockney to shades of grey has produced a type of ambiguity in which the artist seems to be on much the same plane as, and therefore a part of, the painting acting as a backdrop. The same shot in colour would have far less impact.

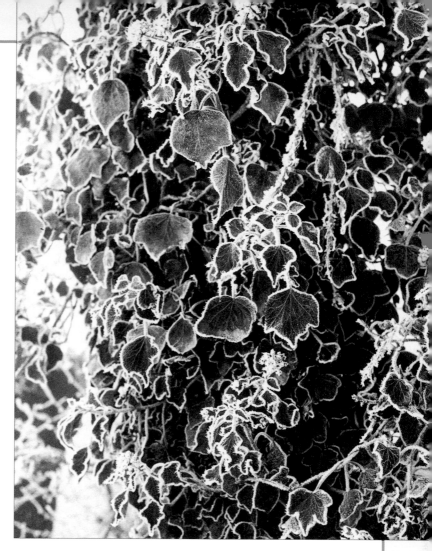

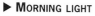 **▶ MORNING LIGHT**
Once colour is extracted, pictures
of plants become studies in texture
form and shape. In order to capture
the night's frost still fringing the
leaves of these garden plants, it
was necessary to shoot well before
the sun reached them. By taking an
exposure reading from the bright-
est highlight in the scene, the
shadowy parts behind the foliage
have been thrown into deep
shadow, creating a strongly three-
dimensional effect.

that has to do only with the way that you
see and interpret the subject in the camera's
viewfinder. In other words, it allows you to
stamp your own identity on the image.

Preconceived ideas

There are many preconceptions regarding
the types of subject suitable for black and
white and those that are best tackled in
colour. Many people may feel, for example,
that the black and white medium is most
suitable for 'art-type' pictures, those that are
not concerned with normal, everyday
'humdrum' subject matter. Others say that
portraits of men look fine in black and white
because it can emphasize their masculinity
while those of women really need the extra
femininity that colour brings.

Yet others say that photographs of
nature or natural history subjects – such as
landscapes, flowers, trees, and so on – seem
flat and lifeless without colour, or question
the point of taking locations and holiday
shots in black and white because you can't

see what the place really looks like. None of
this is in fact true.

There is no type of subject that is best
shot in colour or any other that suits black
and white over and above colour. The suc-
cess of any photograph, taken on any type of
film, depends on the photographer's aesthetic
sensitivity to capture the nature of the sub-
ject – on his or her perception, vision and
imagination. Also vital is the technical abil-
ity to select the best aperture and shutter
speed, the most appropriate viewpoint, focal
length and the moment to shoot

Although colour has been universally
available for the past 30 years or so, some of
the most evocative and powerful images that
have ever been taken are in black and white.
Perhaps this is in part due to the fact that a
black and white image allows the picture's
audience to exercise its imagination –
because the image is not in any way a literal
rendition, there is no one way to interpret it.
Another part of the answer may be that the
black and white medium simplifies the

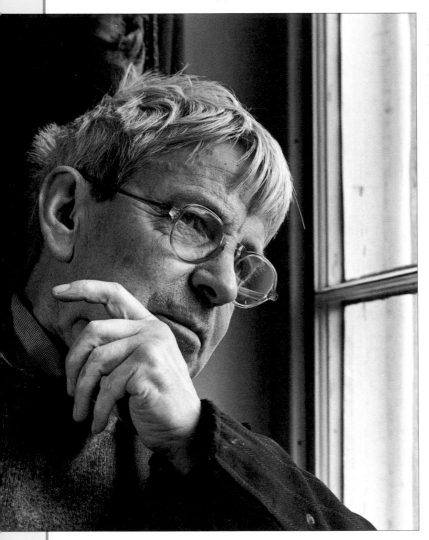

◀ **WINDOW LIGHT**
Positioning your subject adjacent to a window to take advantage of natural sunlight often produces a dramatically contrasty image, with some parts of the subject brightly lit while others are seen in deep shadow. And because all of the light is coming from just one direction – the window – texture is likely to be an important aspect of the composition, especially since there is no colour to compete for attention and distract the eye.

image, stripping it down to its essential elements – light and shade, shape, form and texture – and, as a result, it can have much more of an impact.

The intention behind every photograph is to convey an idea. If you have a clearly thought out notion of what that idea is then there is no reason why a black and white photograph of, say, a flower specimen – which, in reality, is bursting with vibrant colour – should not make a successful black and white study.

Taking control

One major advantage that black and white has over colour photography is that it is relatively simple to maintain control over the appearance of the final image right through from taking the picture to developing the film and then finally printing up the

resulting negatives. Even after all my years as a photographer, the really special thing about the black and white darkroom is that processing still takes place in open trays. Even on your first attempt at processing and printing you should be able to achieve a reasonable image. And the magic of seeing your print start to appear in the developing tray after a few seconds never completely wears off. Again, however, colour workers can follow this process in the same way, but the expense involved is far higher and learning to achieve good, consistent results is far more difficult.

The chemicals used in black and white film and paper developing are relatively inexpensive to buy when compared with their colour equivalents, and fewer of them are required. Black and white films and papers are also much more forgiving of any

small processing errors you may make. The recommended temperature range for the critical stages of colour processing, for example, calls for accuracy within a few fractions of a degree, and each chemical stage also needs to be very precisely timed. This is not meant to imply that you should not endeavour to achieve a high degree of professionalism and accuracy in your black and white darkroom technique. This is vital since it is the only way to guarantee consistently good and repeatable results.

It is by manipulating the tonal range – the shades of grey between black and white – that you control the mood and atmosphere of the monochrome image. To help you achieve this, black and white paper is available in a wide range of contrast grades and you also have the opportunity to vary the

length of exposure of different areas of the printing paper in order to lighten or darken specific parts of the image.

Light sources

An immensely liberating aspect of working in black and white is that you do not have to worry about the different colour temperatures of the various light sources you could use to illuminate your subjects.

All light has a specific colour temperature depending on its source. Light from the sun

▼ **RANGE OF TONES**
By filling the foreground with haphazard and jagged shapes, all picked out in well-defined tones, the seedy and slightly derelict nature of this waterfront scene has been superbly conveyed.

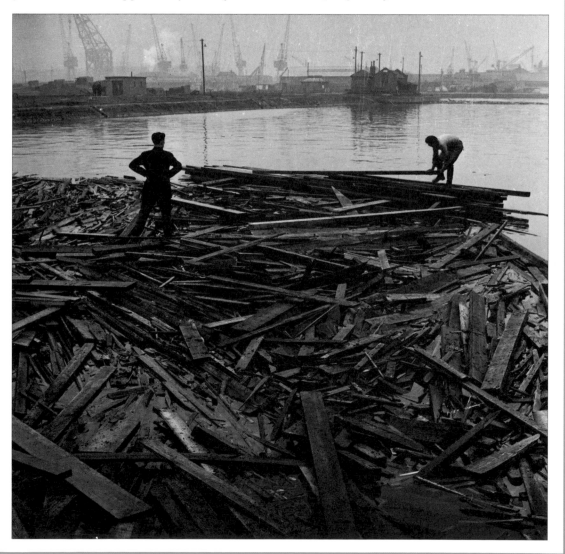

or that from a desk lamp looks pretty much the same colour to the human eye. This is mainly due to the fact that the brain adjusts our perception so that an object of a known colour – a white handkerchief, for example, or a green apple – illuminated by any regular type of light source appears to be the colour we know it should be.

However, colour film can make no such adjustment, and so colour photographers have to ensure that light sources with radically different colour temperatures are not used in the same shot. When working in black and white, though, you can mix light from the sun with that from, say, ordinary domestic room lights with impunity, since the tonal response of the film will not be affected in any way – although contrast may not then be consistent. Your concern is primarily the relative strengths of highlights and shadows and the overall intensity of the lighting in relation to the speed of your film.

Filters

An obvious assumption to make is that black and white film is not sensitive to the different colours in the world around us. This is of course not the case, but instead of reproducing the different wavelengths of 'white' light as different colours, it reproduces them as different shades of grey.

Basically black and white film reproduces dark colours as dark tones and light colours as light tones. However, it is not uniformly sensitive to all the different colours of light and this fact can lead to the tonal equivalents of some colours looking

▼ DOUBLE EXPOSURE
This intriguing night-time image was taken by exposing the flame and tower through a tube of cardboard, and then covering the tube to shield that part of the film and moving the camera while the shutter remained open in order to cause the lights of the oil refinery to blur and streak.

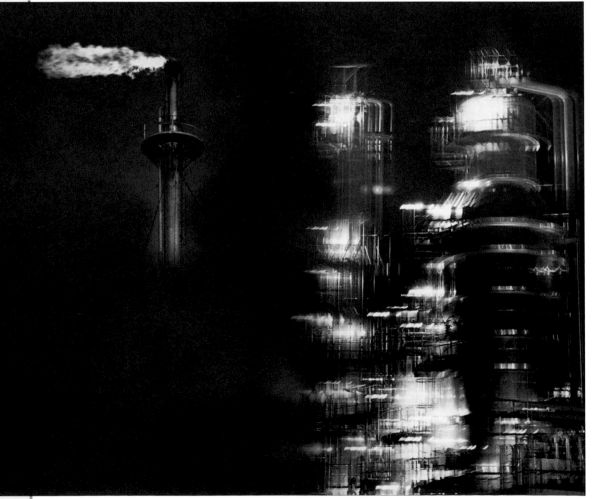

▶ **ORDERING YOUR PRIORITIES**
The right framing and exposure, and selecting the best moment to shoot, are all far more important factors than whether or not the image is in colour or black and white. This portrait is so engaging, the absence of colour simply has no significance.

very similar when shot on black and white film. The colour blue is an obvious example to use to illustrate this point, since it tends to print as a very pale tone. This can be a problem in landscape shots, for example, or in any picture in which an area of blue sky is prominent, since it will often appear as a featureless expanse of white almost indistinguishable from any clouds that may also be present. You could burn in that part of the image by giving it extra exposure at the printing stage, but this can produce a grainy and an unnatural-looking area of tone.

To overcome this type of problem, as well as to manipulate the tonal response of the film to convey a particular mood or atmosphere, you can use a wide range of coloured filters over the camera lens (*see pp. 36–7*). An orange filter, for example, strengthens the film's tonal response to blue, thus making skies more prominent. A deep red filter has an even greater effect, turning a blue sky nearly black if the film is slightly underexposed as well. An orange filter can also be used to make vegetation appear as a darker tone, while for the reverse effect use a green-coloured filter.

How this book is organized

The first chapter is an introduction to the components that make up a successful black and white image, including the principles of basic composition and framing. In the next three chapters, dealing with the popular subject areas of still lifes, portraits and landscapes, you will see how these principles can be applied in many different areas of photography. The final chapter of the book is a complete beginner's guide to the darkroom, showing how to set up your own darkroom at home, process film and then make a print. Finally, if you want to go a little further, there is also guidance on how to tone and hand colour black and white images.

Basic principles

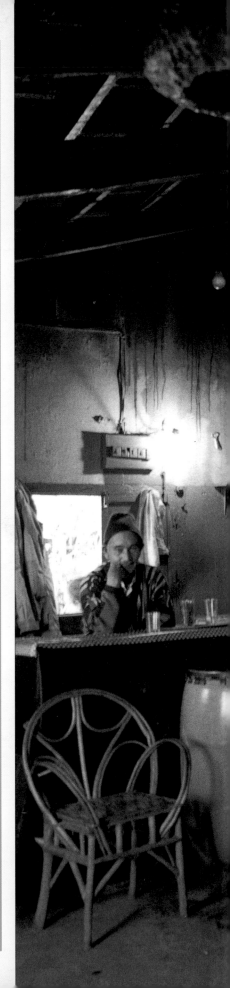

L IKE ANY OTHER AREA of creative endeavour, good photography depends on the imagination, talent and application you are able to invest in the subject. There are, of course, certain constraints you need to recognize in order to achieve, for example, a 'properly' exposed negative – one that contains the right distribution and densities of tones – from which to make a print. It is also important to understand the relationship between the lens aperture and camera shutter speed in terms both of correct exposure and subject appearance. Modern cameras almost all have some form of semi- or fully automatic exposure system. You may, however, want to override this in order to increase or decrease the area of sharp focus surrounding your subject (the 'depth of field') by choosing a particularly small or wide aperture. Or you may want to override the automatics and select a very brief or very long shutter speed in order to freeze subject movement or to record it in a blurry, impressionistic fashion.

These technical aspects of photography can be quickly learned. What is harder, and takes much more time, though, is learning to translate in your mind's eye the colourful world you see around you into the range of black through white tones that your film will produce. This takes practice, and there are no short cuts. In the same way, there is no substitution for understanding how the angle of light, or competing light sources, influence the apparent shape or surface characteristics of your subject, or how framing, camera angle and focal length all come together to create effective compositions.

▶ **IMPROVIZATION**
The dimming light in this café in Morocco meant using a long exposure, with the lens set at f8 for adequate depth of field. A table top became an impromptu support to prevent camera shake at 1/15 sec.

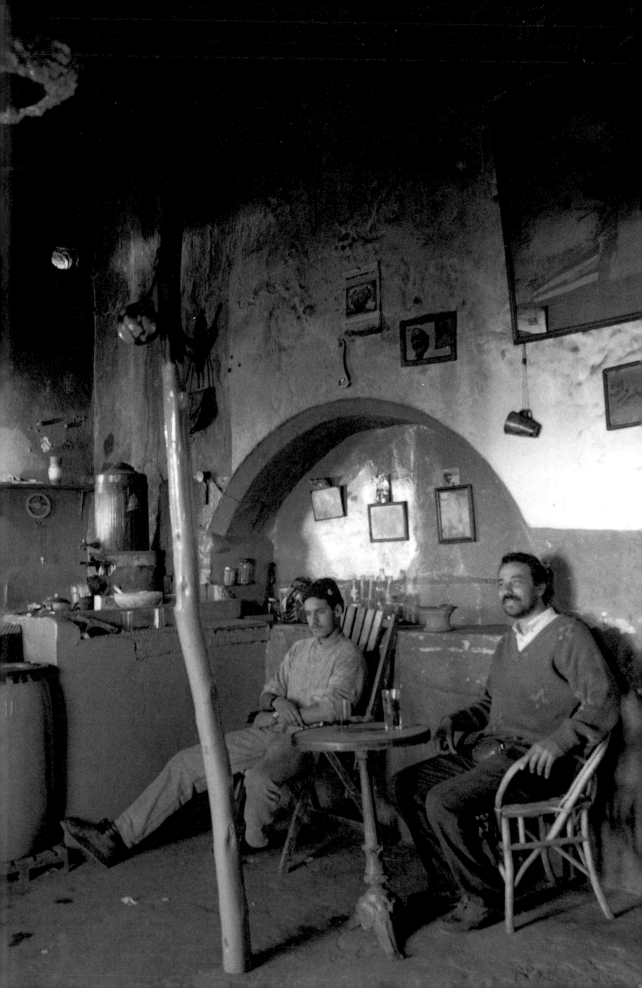

Colour into black and white

IT TAKES SOME AMOUNT OF PRACTICE to learn to see the world of colour in tones of grey. If you have access to a second camera, probably the best way to make this learning transition is to load one with colour slide film and the other with black and white. On a day with a good range of weather conditions – from clear skies with bright sun through to cloud and a more gloomy aspect – take a range of shots of the same subjects using both cameras.

Film types

For this learning exercise it is best to use slide film rather than colour negative film. Slide film gives extremely accurate colour rendition because it is designed to give a direct positive image without any intervening printing stage. It is rare to find a film laboratory, especially one using automatic processing machinery, that is capable of producing colour prints that are true to life across the whole range of colours.

Subject types

When choosing subjects for this exercise, look for variety. A broad view with plenty of foliage and a large expanse of blue sky with prominent clouds is a good example. This will allow you to see how the black and white film handles the different shades of green and, especially, the sky area: unless you use coloured filters over the lens, blue skies can often be disappointing in black and white (*see pp. 36–7*).

Try for close-up comparative shots as well. A boldly patterned multicoloured subject would be ideal to allow you to see how individual colours translate into black and white and also to see if the various

This reproduction shows an accurate balance of colours, as would be seen by the unaided eye.

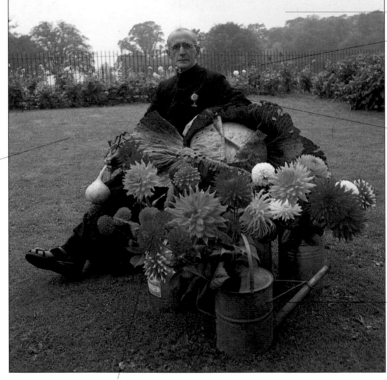

Pale blue sky.

The railings and background foliage appear well separated.

The colour of the cassock is dominant here. There is no sense of how the material might feel if it was actually touched.

The large expanse of green lawn seems to engulf the subject. Note how the colour is more saturated in the shadow areas.

The watering cans are quite pronounced in colour.

The foreground flowers in reds, oranges and yellows contrast so powerfully with the surrounding green that they initially hold the viewer's attention away from the remainder of the composition.

shades of grey allow you to distinguish between various colours when they are adjacent to each other.

Processing and printing

Whereas most people send colour films to a laboratory for processing, in black and white it is possible to handle this aspect at home in your own darkroom (*see pp. 126–9*). You will then have the chance to experiment with a variety of film and paper developers, each of which will produce slightly different tonal responses. The paper's contrast grade also has an effect on the appearance of the print (*see pp. 136–7*), as do such techniques as dodging and burning in (*see p. 140*).

This reproduction shows the scene as it would appear if it were shot on black and white film with a pale orange filter over the lens.

The orange filter has produced a little tone in the sky, which otherwise would have appeared completely bleached out.

Background foliage and railings have reproduced as tonally very similar and don't show the same separation as in the colour version.

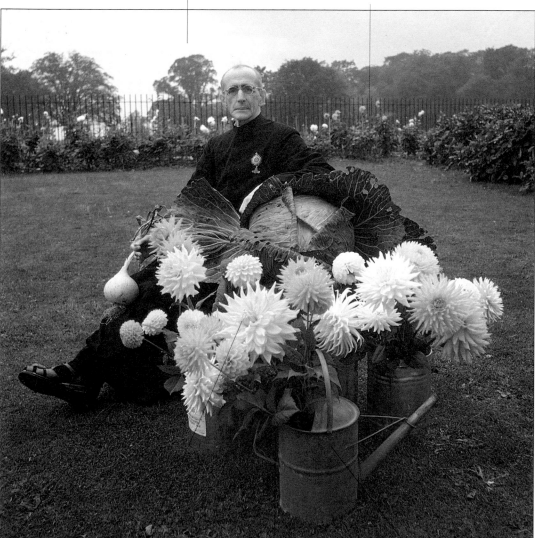

With colour removed, the cassock now has more of a tactile quality.

The orange filter has lightened the tonal reproduction of the flowers, which otherwise might have appeared too similar to the green of the cabbage

Note how darker colours generally reproduce as darker tones as compared with the lighter colours.

In black and white, the watering cans seem less pronounced.

Tonal range

INSTEAD OF COLOURS, the image of a black and white print is composed of shades, or tones, or grey, ranging between the extremes of solid black and stark white. Unless your intention is to go for a high- or low-key image (*see pp. 20–1*), then the 'ideal' negative is one that you can print on a normal grade of paper – say, grade 2 (*see p. 136–7*) – and that contains the widest possible range of grey tones between the two extremes.

This is not an invariable rule, however, and it is quite usual for photographers to expose a negative knowing that it will contain a restricted tonal range, and then to enhance this even further through their choice of developer and paper grade in order to suit the needs of the subject. Bear in mind, though, that most prints will have additional impact if they contain at least small areas of dense black and pure white.

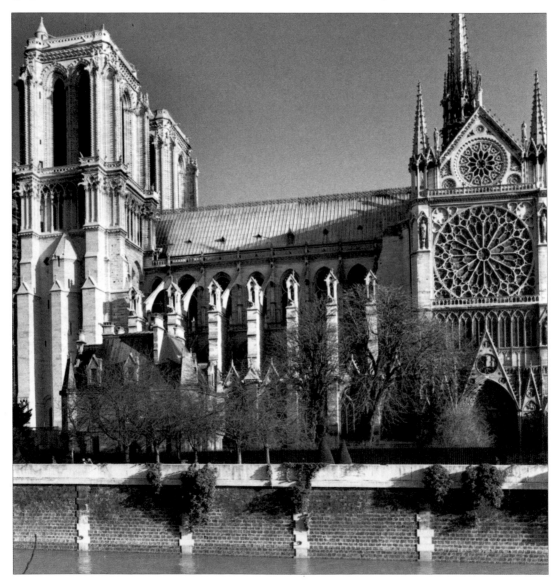

▲ FULL TONAL RANGE
A complicated image such as the façade of this cathedral coupled with strong, directional sunlight is an ideal type of subject to bring out the range of tones black and white film is capable of producing. The presence of bright white and dense black areas also gives a strongly three-dimensional result.

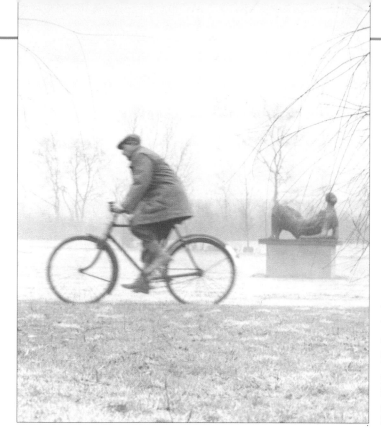

◄ LIGHT-TONED RESULT

This portrait of the artist Henry Moore cycling past one of his sculptures has a tonal range restricted to the light end of the scale. The darker frame of his bicycle, the shadow area beneath his coat and the sculpture itself, however, help to 'sharpen' the overall appearance of the print.

▼ DARK-TONED RESULT

This view of a refinery was taken against the light and most of the subject is therefore seen in shadow. This is relieved by the small, but intense, highlight in the middle of the frame, which attracts the eye and also prevents the image appearing flat and two-dimensional.

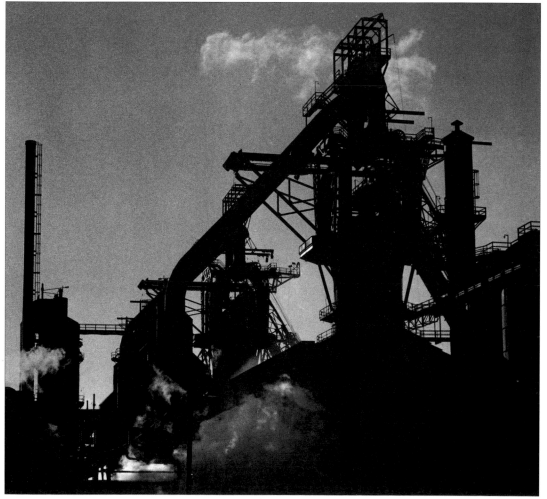

High contrast

IN PHOTOGRAPHIC TERMS, contrast refers to the exposure difference between the brightest highlight in a scene and the deepest shadow. This is relevant because film is capable of recording subject detail in both of these parts of the frame only if the exposure difference is not too great. It is not possible to put a precise number of f-stops on this difference, however, because brands, and speeds, of film differ in their response.

In general, it is reasonable to assume that a slow-to-medium film – say, ISO 200 – will be able to record a wider contrast range than a fast film of ISO 800.

In the images shown on these pages, the high-contrast results you can see are due to a variety of circumstances. In the building opposite, it is the tonal contrast of the subject itself, being composed of black against white. In the portrait, direct window light is reaching only one side of the subject's face, and so the other side is more in shadow. In the image below, the camera angle shows the subjects framed against a light, bright sky and so they appear as dark silhouettes. In each case, though, note how by using high contrast a real sense of impact has been imparted to the images.

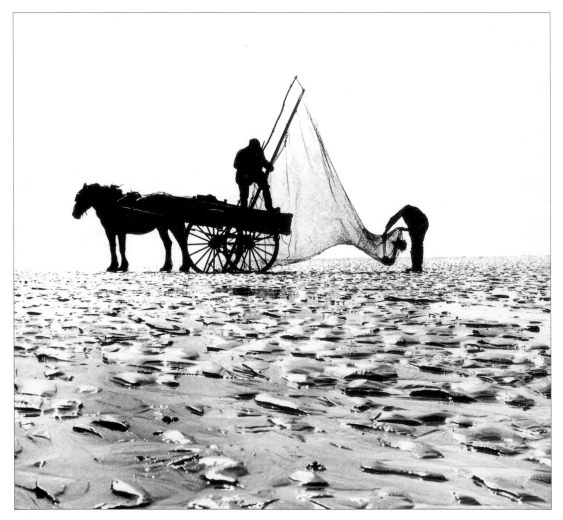

▲ CAMERA ANGLE
A low camera angle looking up at the subjects shows them framed by a wide expanse of bright sky. By setting exposure for the brightest part of the scene, everything else has been reduced to a series of graphically powerful shapes. The foreground mud flats reflect light strongly, so they appear very bright.

▶ **WINDOW LIGHT**
In this portrait of the author Dame Agatha Christie the contrast on her face is obvious. A white cardboard reflector positioned on her shadow side was used, however, to return a little light and so prevent the difference in exposure from becoming too extreme.

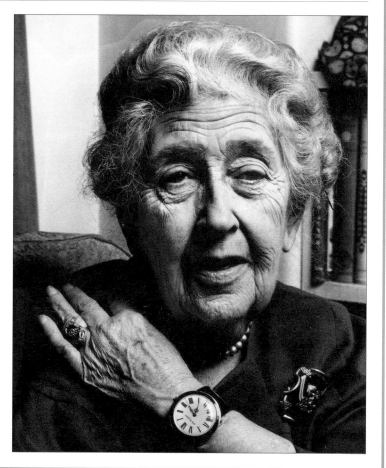

▼ **BLACK AGAINST WHITE**
The high contrast evident in this picture of the façade of an elegant Elizabethan building is the result of the stained-black woodwork seen against the white-painted infill walls.

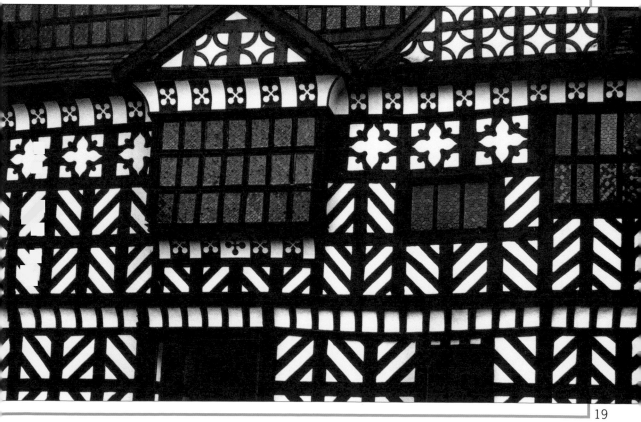

High key and low key

Two types of contrast effect are known as high key and low key, and each imparts its own particular 'atmosphere'. In high key, the lighting produces tones that are predominantly light and any dark areas should occupy only a small area of the frame. The open, airy feeling given by a high-key picture is ideal for certain types of subject (*see right* and *below*). To reinforce high-key lighting, take your exposure reading from the darkest available area of the picture so that the aperture widens (or the time the shutter remains open lengthens).

A low-key picture is the opposite. In this type of picture, the lighting means that dark tones predominate and the type of atmosphere created is often dramatic, as you can see opposite. Any light tones or highlights should occupy only a small part of the picture area. To emphasize low-key lighting, take an exposure reading from the brightest area of the frame. In this way, the aperture will close down (or the length of time the shutter remains open will shorten).

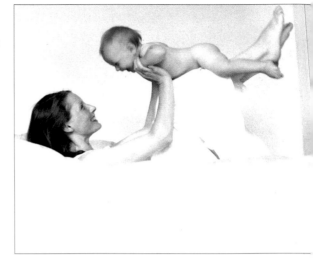

▲ **MOTHER AND CHILD**
Delicacy is one of the characteristics of a high-key picture. This scene of a mother and baby is flooded with light, matching the sunny expressions of the subjects.

▼ **MISTY LIGHT**
One of the effects of mist is that the particles of moisture trapped in the air bounce the light around, making a high-key result relatively easy to achieve.

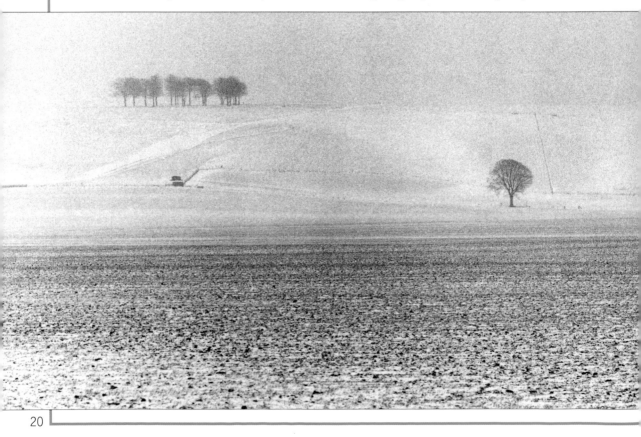

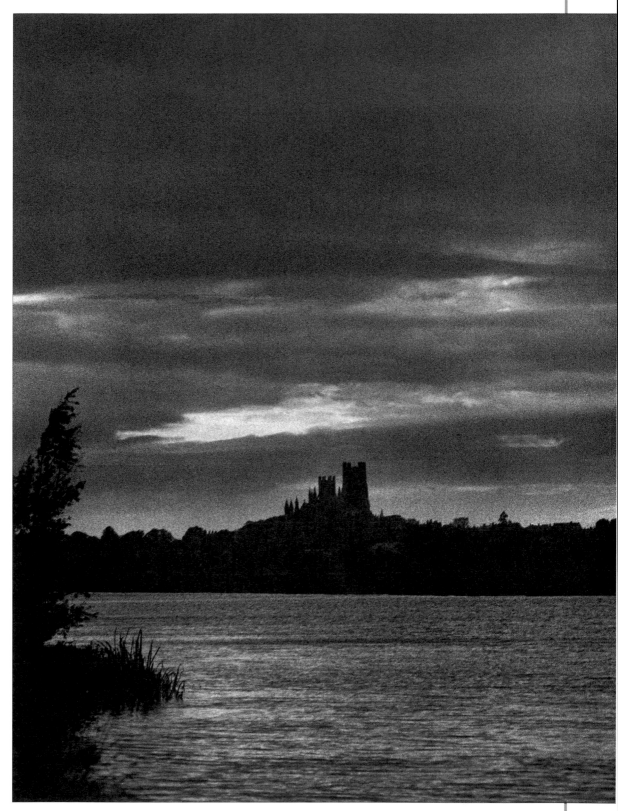

▲ STORMY LIGHT

The low-key interpretation of this scene is the perfect way to capture the brooding, slightly ominous, quality of the castle on the far bank. The exposure reading was taken from the bright area of sky showing through the threatening storm clouds, and this caused the rest of the scene to underexpose to varying degrees.

Image grain

AT SOME STAGE OR ANOTHER you will hear photographers talking about 'grain'. The emulsion of a strip of film (or a sheet of printing paper) is made up of minute grains of a light-sensitive material, known as silver halides. It is the chemical change that takes place in the structures of these grains that makes up the image you see as a negative (or as a print).

In a slow film – anything up to about ISO 125 – the grains are small and densely packed. The result is that, when enlarged to a normal degree, the individual grains cannot be seen on the print. Such a result would be known as fine-grained. The emulsions of fast films,

however – such as ISO 800 or higher – contain large grains of silver halides. Large grains have a larger surface area and, thus, are more light sensitive. The drawback, though, is that when enlarged these grains show up as a distinct pattern, although in modern emulsions this is not so much of a problem.

The appearance of grain is not always a disadvantage. Sometimes specific film developers are used to accentuate its appearance, or just a small part of a slow-speed negative is enlarged in order to emphasize the grain pattern. You will also see from looking at the pictures on these pages that grain is always more apparent in the light-toned areas.

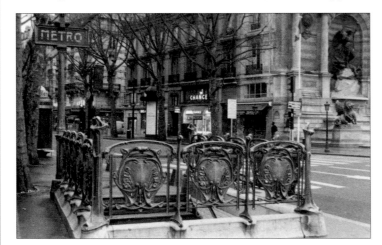

◀ ▼ DEGREES OF ENLARGEMENT
These two images demonstrate how grain becomes more noticeable the greater the degree of enlargement. The version on the left is the scene of a Parisian metro entrance printed from the whole of an ISO 200 negative. The version below is an enlargement from just a small part of that same negative. You can see immediately that the grain is very much more pronounced. Note, too, that the grain is most obvious in the neutral-toned parts of the image.

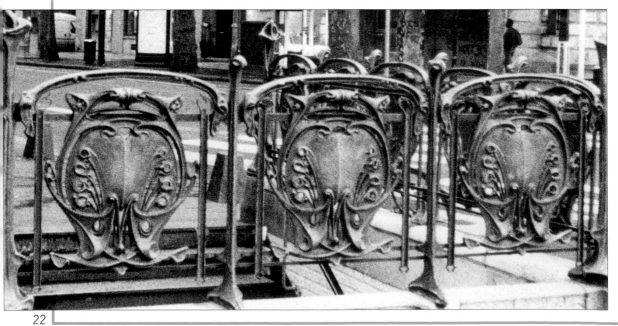

▶ SPEED ENHANCEMENT

The ISO 400 negative that produced this print was developed in a special speed-enhancing developer. As a result, the grain response in parts of the image, especially between the subject's fingers, has taken on an almost tangible, three-dimensional quality.

▼ GRAIN FOR EFFECT

In this industrial scene of a pyramid of tailings from local mine workings, the pronounced appearance of the grain helps to conjure up an atmosphere of the degraded landscape associated with mining areas.

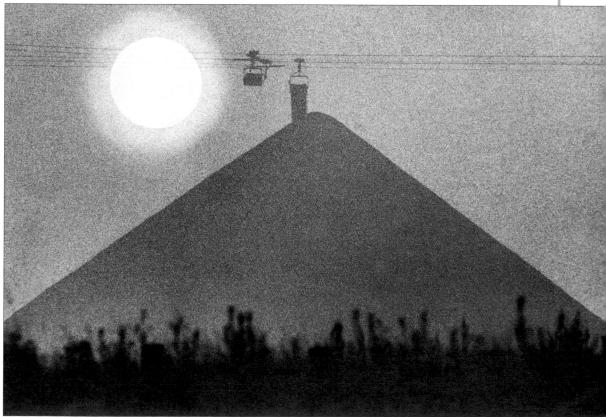

Texture

ONCE YOU EXTRACT COLOUR from a scene, other surface characteristics of the subject assume greater importance. One of the most telling of these is texture, because it is the degree of roughness or smoothness of the subject that adds vital visual information and interest to a photograph. Surface texture also gives you the sense that the picture you are looking at has a tactile quality and so helps you to imagine what it would be like if you could reach out and actually touch whatever is depicted.

Texture becomes evident when light strikes the surface of your subject at a distinct angle, such as in the early morning or late afternoon when the sun is low in the sky and rakes across the field of view of your camera lens. This has the effect of illuminating the high points and casting shadows that leave the corresponding hollows, or low points, in darkness. Moving in close, this can give the skin of your subject a three-dimensional reality; in a landscape, it can make you feel as if you could literally walk into the frame.

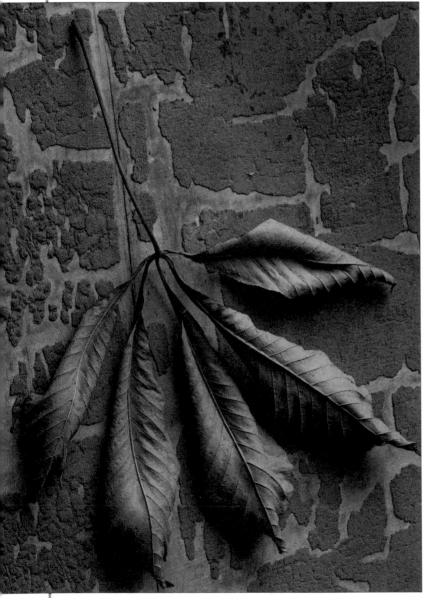

◀ **ISOLATED DETAIL**
The low angle of the light in this still-life study illuminates only the highest surfaces of a dried and curling leaf, leaving pools of cool shadow that give it a very tactile quality. Note, too, how the roughness of the supporting stonework has been accentuated.

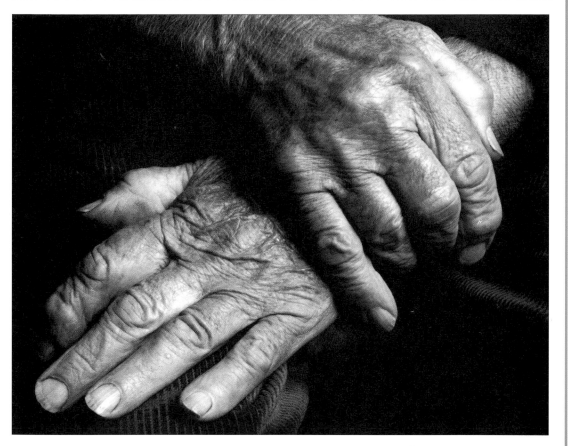

▲ SKIN
The light for this close-up of the wrinkled hands of an 80-year-old man came from daylight entering the room through a small window. The directional quality of window light can cause problems of contrast (*see pp. 18–21*) in a more general portrait, but here the extreme difference between light and shadow produces a composition in which texture is the main subject.

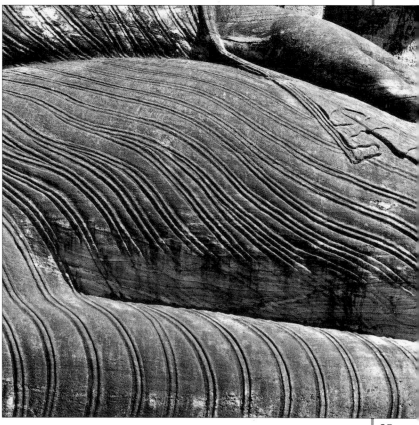

▶ EMPHASIS THROUGH SELECTION
By selecting just a small part of a large subject – here the undulating base of an enormous stone statue of Buddha – you can emphasize the texture that would otherwise have passed unnoticed if all the statue had been shown. Note how, as well as showing texture, the contrast between light and shade produces a sense of depth.

Leading the eye

W HEN LOOKING AT any photograph, we instinctively seek some sort of order in the visual information it contains. You can exploit this preference for order by selecting a camera angle and framing to give the strongest impression of your subject and to lead the viewer's eye through the image in a particular way.

Line, tone and perspective

One way of leading the viewer's eye is to link subject elements by lines occurring naturally in the scene, such as those created by a flight of steps and balustrade, for example, leading to something you wish to stress.

Tone can also be used to link different parts of the frame, with the eye using areas of similar tonal value to explore an image in much the same way as you would use stepping stones to navigate a course. Perspective, too, is a device you can exploit, utilizing diminishing scale, converging parallel lines and overlapping forms to suggest a way of interpreting the image.

▼ EYELINE
The tendency when seeing a person looking at something is to follow their gaze – a perfect way of directing the viewer's attention to another part of the frame.

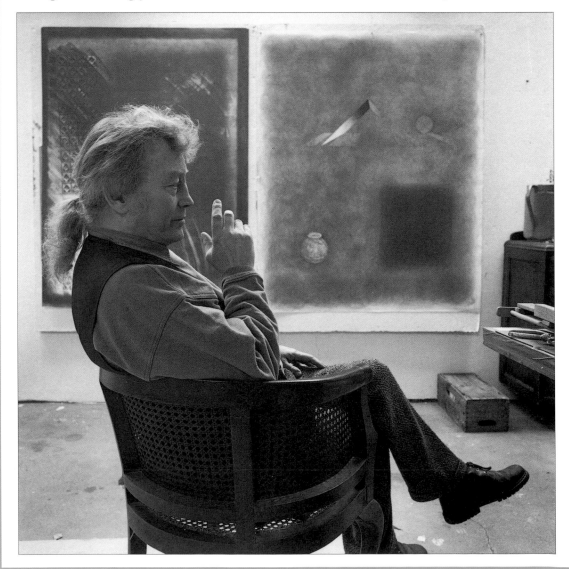

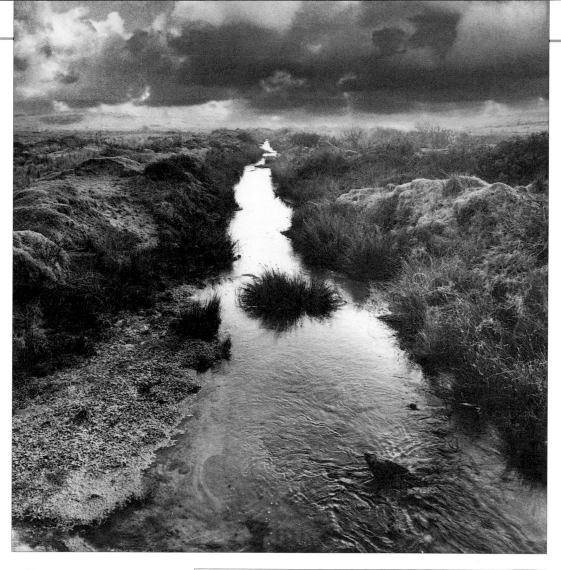

▲ TONE AND PERSPECTIVE

In this moorland image, a ribbon of silver leads the eye from the immediate foreground to the far distance. The apparent convergence of the lines of the river banks, which seem to draw you deeper into the frame, emphasizes the route our eyes should take.

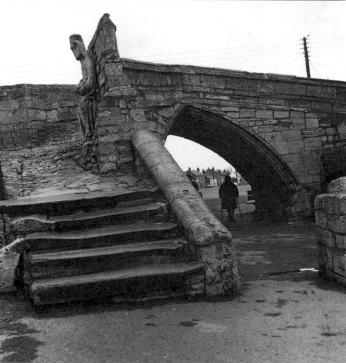

▶ NATURAL LINES

Here you can see how line has been used to direct you around the image. The lines of the balustrade and steps lead you up to the top of the bridge where the sweep of stonework carries you across.

Framing the subject

THE VISUAL CONTENT of a photograph can often be simplified and strengthened by choosing a camera angle that shows the main subject framed by other elements of the composition. Frames can be of many different types and often all you need do is shift your camera position until they and the subject align properly when seen through the camera's viewfinder.

Focal length and aperture
Frames can be shown sharply focused, and so forming an integral part of the composition. Alternatively, they can be soft and indistinct, and used largely to fill what would otherwise be an uninteresting part of the frame – such as an expanse of flat-toned sky or an uninteresting foreground. For the former effect, a combination of a non-telephoto lens and a small aperture will usually render the frame in focus, assuming that it is not too close to the lens. For the latter effect, a long lens and a wide aperture will usually show it as a soft blur, especially if you position the frame close to the lens.

Tonal rendition
When working in colour, you need to take the colour of the frame into account to make sure it does not distract attention from the main subject. In black and white, however, your only concern is with its tonal value and whether it is sufficiently different so as not merge with or confuse the subject.

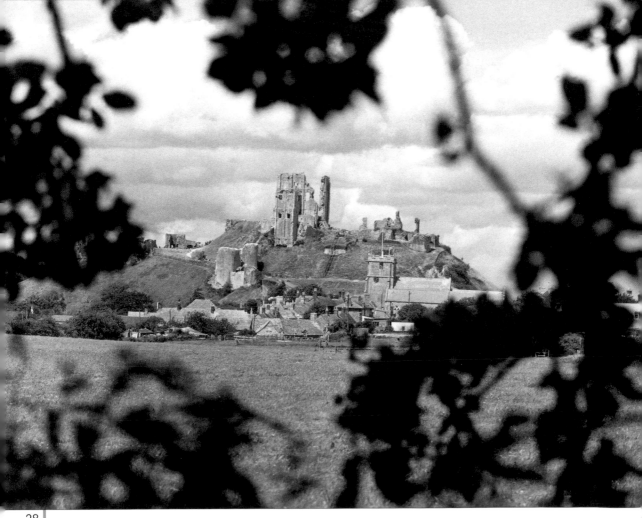

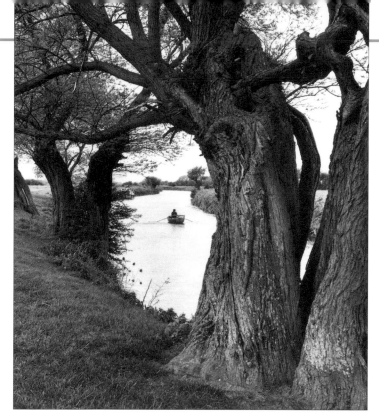

◀ **SHARPLY FOCUSED FRAME**
In this example, the gracefully curving trunks of the near and distant tree meet to form a natural arch through which the subject can be seen. A 35mm moderate wide-angle lens was used with an aperture of f11, showing the whole frame equally sharp.

◀ **SOFTLY FOCUSED FRAME**
In this view, a frame has been created by shooting through a clear area in the foreground foliage, which was almost touching the front of a 135mm lens. With the foliage this close to a long lens, an aperture of f16 was selected, in order to ensure the distant subject was sharply focused, in the full knowledge that the curtain of leaves and branches would appear almost transparently soft.

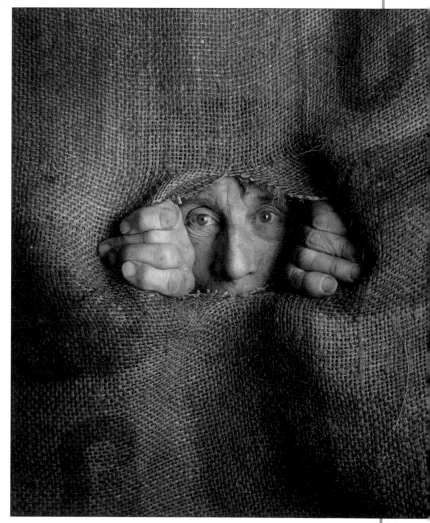

▶ **FRAMES WITHIN FRAMES**
The frame of sacking material used in this picture has been integrated with the image of the subject. This light-hearted portrait shows the subject peering out through a slit in the material, and his hands, widening the gap, form yet another frame around his face.

Unusual viewpoints

Photographs often gain additional impact when they show the subject from an unusual viewpoint. Even if your first view of a subject is favourable, take the time and trouble to explore different camera angles and perspectives. For example, drop down on one knee so that you see the subject through the viewfinder from a lower-than-normal viewpoint. If a chair is available, try viewing your subject from an angle greater than normal eye-level, which is the height from which the overwhelming majority of

shots are taken. If you are shooting outdoors, a rigid-framed camera bag makes a convenient shooting platform, giving you the advantage of a little extra height.

Unusual viewpoints can also be achieved by isolating just the crucial picture elements. Finding a camera position that strips away the clutter allows the viewer to concentrate on your perception of the scene. You can also use the darkroom to advantage here (*see pp. 138-9*) by pre-visualizing how the image could be cropped to strengthen its content.

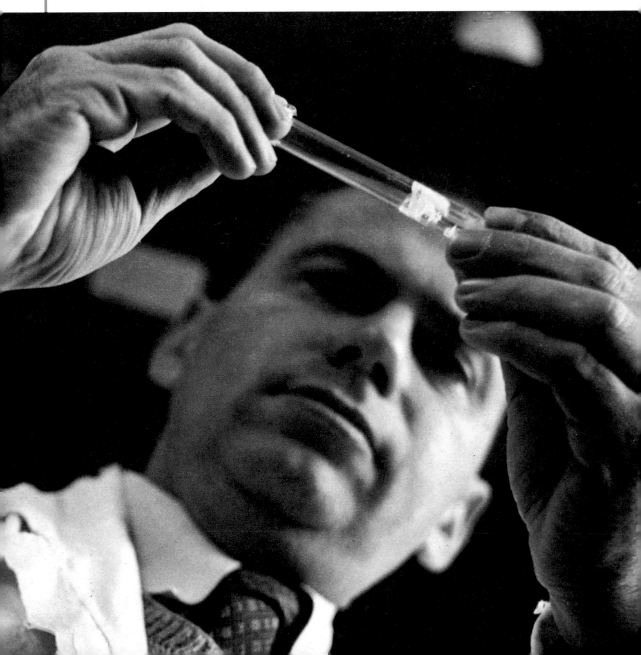

▶ OFFSET ELEMENTS

To produce this picture I had to shoot from a low angle. What I wanted to show were the nurse's anxious eyes toward the bottom of the frame and the object of her concern – the drip machine – at the extreme top. By offsetting and isolating the subject elements in this way, a definite tension is created as the viewer's eyes flick between the two.

◀ DEPTH OF FIELD

A low camera angle shows a doctor against a plain, non-distracting background. A 50mm lens, set at f2.8 and positioned very close to his hands holding the phial, ensures that depth of field – that area of sharp focus surrounding the point of true focus – is limited.

▼ SHOOTING DOWN

To gain the height for this photograph, I climbed to the top rung of a tall stepladder and shot downward. This viewpoint makes it appear almost as if the powerful highlight shining on the studio floor is, in fact, the light source, and the model is somehow transfixed to its outside surface.

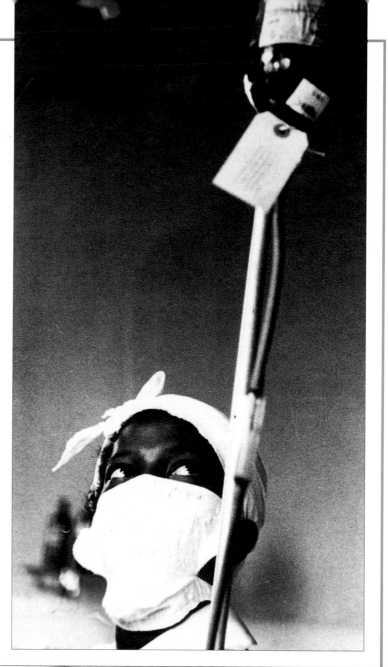

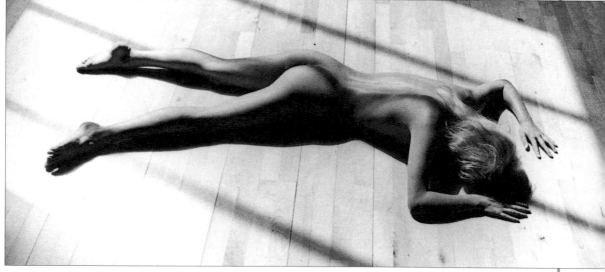

Movement – recording action

YOUR MOST IMPORTANT camera control for recording subject movement and action is the shutter speed dial. The shutter control is calibrated in fractions of a second, such as 1/500, 1/250, 1/125, 1/60, and so on all the way down to very long exposure times of 1/2 sec and then 1 full sec or more. Note that each shutter speed either halves or doubles the length of time the shutter remains open.

When deciding which shutter speed to set, you need to take two things into account. First, can the shutter speed be compensated for by an appropriate aperture to ensure correct exposure? For example, if you were to set 1/2 sec on a bright, sunny day with fast film loaded in the camera, then even the smallest aperture your lens has to offer may result in overexposure. Conversely, if the light levels are poor and you have slow film

loaded in the camera, 1/1000 sec may give underexposure even with the widest aperture.

Second, the length of time the shutter is open determines the way a moving subject appears when printed. For example, if you were to set a slow shutter speed – say, 1/30 sec – to record a speeding car, it is likely to appear streaked and blurry (unless panned). This, of course, may be just the effect you want. Changing to a shutter speed of 1/2000 sec with the same subject, however, would almost certainly result in a sharp, frozen image, which, again, may be what you are after.

▼ **FAST FLASH**
Flash light gives an extremely brief, intense burst of light, fast enough to 'freeze' the movement of the liquid in the bowl when an ice cube is dropped into it. When using flash, the shutter speed is almost incidental.

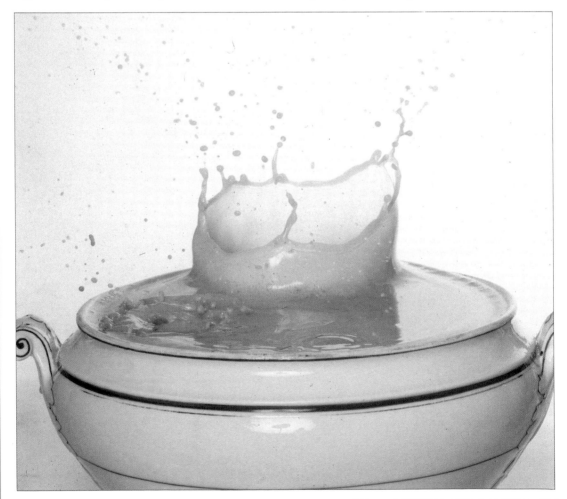

▶ **WHITE WATER**
The speed and unpredictability of a canoeist swept along through a series of rapids requires a fast shutter speed if you want to ensure a recognizable image. The shutter speed used here was 1/500, but you could experiment with much slower shutter speeds as well to record the type of images on the following pages (see pp. 34-5).

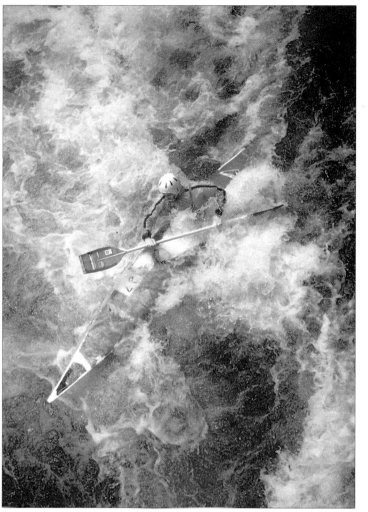

▼ **MOVEMENT ACROSS THE FRAME**
Freezing movement across the frame needs a faster shutter speed than movement at 45° or directly toward or away from the camera. To stop the motor cyclist in mid-air like this, 1/1000 was used.

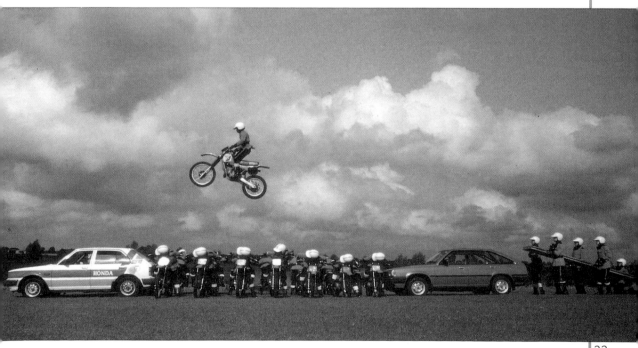

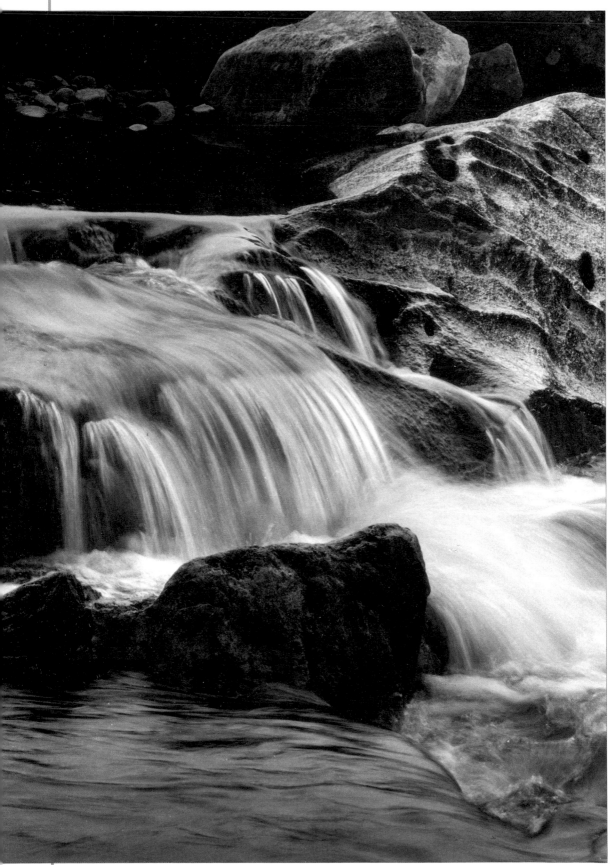

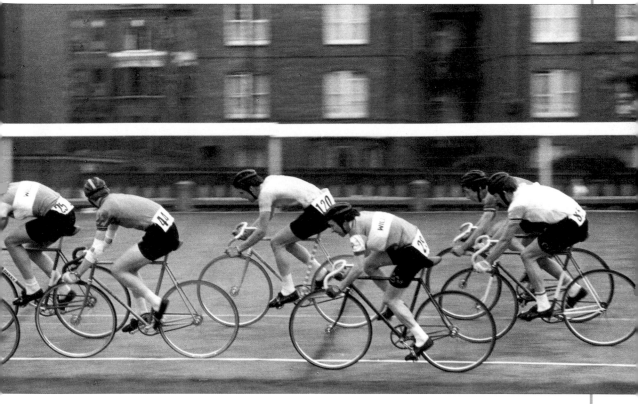

▲ PANNING

To capture the speed and excitement of this cycle race the camera's shutter speed was set to 1/30 sec and the camera panned – moved while the shutter is open to keep pace with the subject. This has given a sharp image of the cyclists while rendering all stationary objects as a series of streaks and blurs.

▼ CAMERA MOVEMENT

Unless you are panning then you will usually want to keep the camera completely still to avoid camera shake. However, in this example you can see how the slightly soft image produced by camera movement has given a real sense of excitement and action to the image of horsemen thundering by.

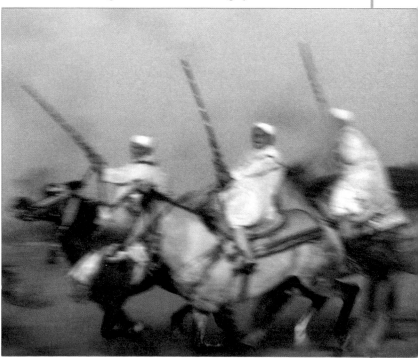

◀ SLOW SHUTTER SPEED

Another way of recording move-ment is to set a slow shutter speed on a stationary camera and so allow the subject to record as a streaky, blurry image, while all fixed or unmoving elements of the scene record sharply.

Filters

COLOURED FILTERS ARE FREQUENTLY used with black and white film to help clearly differentiate the tonal values of colours and also to change the mood or atmosphere of a picture by either lightening or darkening its tones overall. As a general rule, a filter will normally lighten the tone of any colour corresponding to its own and it may also darken other tones. To preview the type of effect a filter will have, hold it to your eye.

A far greater range of coloured filters can be used (for non-special-effects photography) with black and white film than with colour stock. This is because the colour of the filter will selectively lighten or darken the tonal equivalents of colours, rather than producing an overall cast corresponding to the colour of the filter used on the lens.

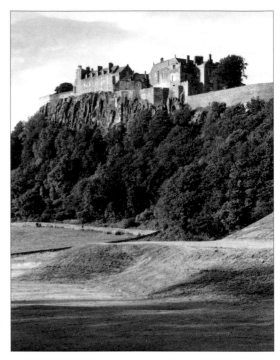

▼ YELLOW FILTER
A deep yellow filter has been used here to darken the grey tone corresponding to the area of blue sky and so help to give the clouds slightly better definition.

▲ GREEN FILTER
As well as making skies appear as a darker tone on the print, a green filter will lighten to varying degrees the tonal rendition of any green foliage visible in the shot.

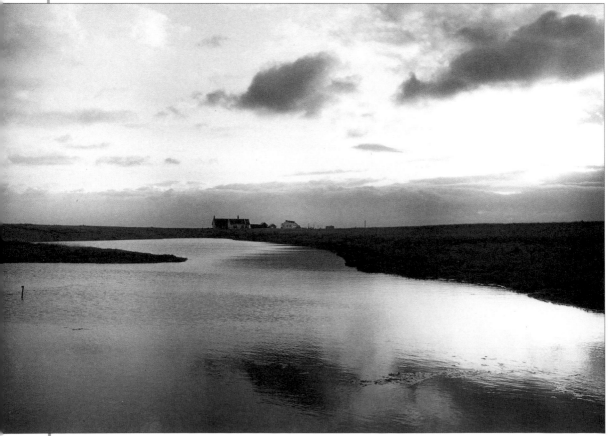

▶ RED FILTER

A red filter has the most dramatic effect on skies, making them appear very dark and forbidding. It has no effect on white clouds, however, and so produces a very contrasty effect. It also makes green vegetation appear very dark toned. If you underexpose by about 2 stops when using a red filter you can make a daylit scene appear as if it were shot by moonlight.

◀ ORANGE FILTER

An orange filter will noticeably darken the tones of a pale blue sky while leaving clouds unaffected. It also has a darkening effect on green foliage, but not as strong a result as you would achieve when using a red-coloured filter.

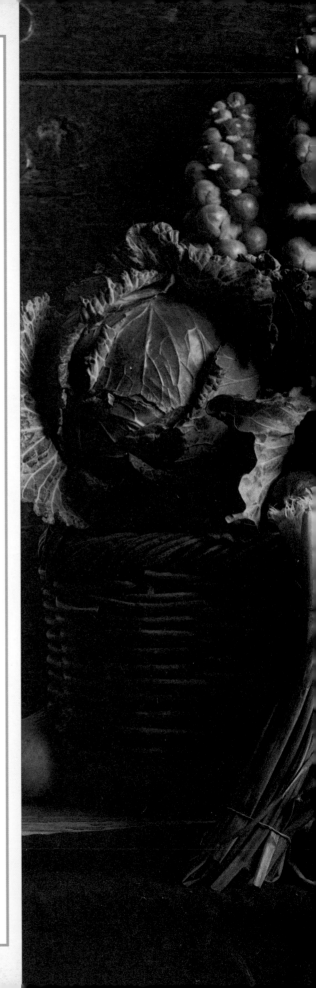

Still lifes

A CAREFUL and methodical approach is the prerequisite for consistently good still-life photographs. Unlike sports and action photography, where you must grab your shots almost by reflex, or even landscape photography, which is dependent on the fickleness of natural light and the ever-changing patterns of light and shade, in still-life photography you normally have the luxury of time.

Use this time to make sure that every element of the composition is exactly right; that the lighting angles will illuminate the appropriate areas of the composition and suppress the others; that your camera position and lens focal length are precisely set to show everything to best advantage. Then check everything through the viewfinder before exposing the film.

Good still-life pictures don't rely on expensive or complicated lighting equipment. Most often you can make do with ordinary sunlight, diffused if necessary to soften its effect. Add a few simple reflectors made of cardboard or kitchen foil to relieve over-dense shadows, and use a basic flashgun to add a highlight. The rest is imagination.

▶ FIND A THEME
It is the obvious connection between the elements in this still-life that makes it such a satisfying composition. The illumination is directional window light with a little fill-in provided by two cardboard reflectors.

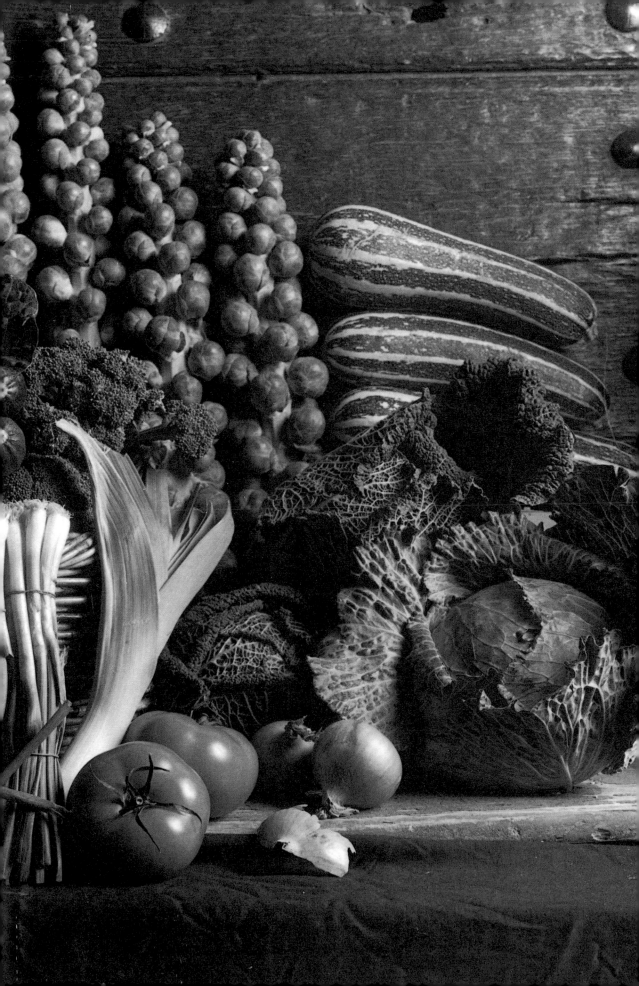

Creating a still-life picture

HAVING DECIDED ON A THEME for your composition (*see pp. 42–3*), the first step is to gather together all the potential elements that could be included in the photograph. Ideally you will want to have more objects than are eventually used in order to give yourself some design flexibility.

The next step is to decide where you want your still-life objects set up. If you are reliant principally on window light, then a shelf or table top close to your light source will be required. If, however, you are using flash or tungsten lighting, or a mixture of these – remember, there are no colour casts to worry about with black and white – then you will have more options to consider, so, in this case, let the availability of an appropriate background sway your decision.

Now, with the camera on a tripod, you can start arranging your objects. In general, it helps to place the largest one first, but not necessarily in centre frame, however; off-centre placement often gives more vitality and makes the remainder of the available space easier to work with. Every time you add an object, or alter the lighting, go back to your fixed camera position and check how it looks through the viewfinder. Then, for maximum sharpness, set the smallest aperture and fire the shutter with a cable release.

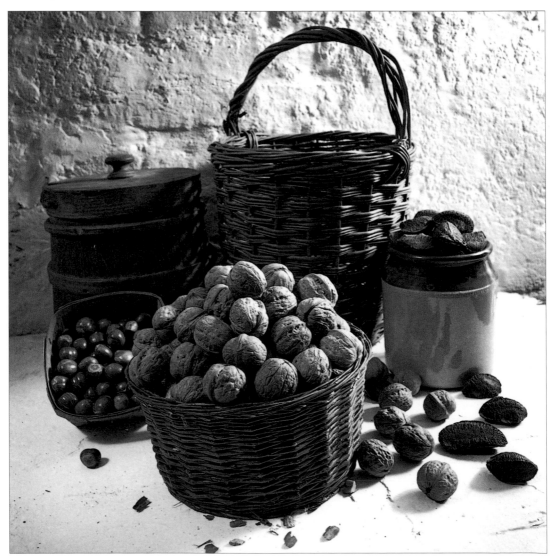

▶ WINDOW LIGHT

This simple still-life composition is lit solely by window light from the left of the jug and tea pot, and much of the interest in the shot lies in the clearly demarcated blocks of light and shade. It is the small details that are so often important, and here you can see that it is the black enamelled rims to these objects that help pull them away from the background, increasing the feeling of depth and distance.

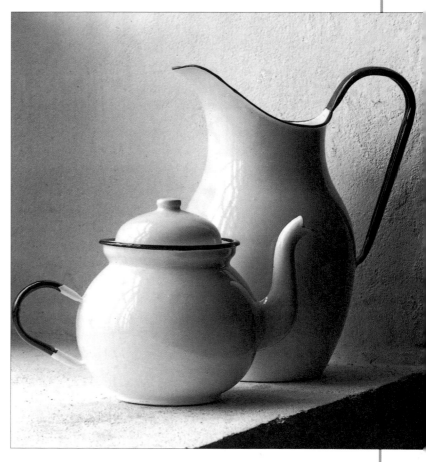

◀ STUDIO FLASH

This still-life composition is lit by contrasty and very directional studio flash set to the right of the group of containers. This has produced a strongly textural image in which you can almost reach out and feel the surface of the wicker and the hard undulating surfaces of the walnuts, brazils and hazelnuts.

▲ DAYLIGHT AND TUNGSTEN

These shots introduce the concept of 'visual weight'. The underlit figure (*above left*), shot with window light, has a heavy, substantial feel. Compare this with the next (*above right*), which, with the addition of tungsten lamps, is more delicate but also more all-revealing and, as a result, it loses some of its sense of mystery.

Aesthetic arrangements

THE POTENTIAL SUBJECT MATTER for still-life compositions is so broad that it can be difficult to know where to make a start. One way to work is to limit your choice of subject elements to things that all have some obvious connection with each other. This connection could be a hobby or activity, such as golf, and the subject elements could then comprise clubs, balls, tees, bag, and so on. Equally, you could select utensils used in the kitchen as the building blocks for a still life,

or a disparate collection of objects that are connected merely by their shape, the material from which they are made or the period in which they originate.

In a small-scale still-life composition, in which the objects are easily countable, you will generally find that it is easier to make a pleasing aesthetic arrangement out of an uneven number of subject elements. Another advantage of starting small is that the lighting scheme is easier to manage (*see pp. 40–1*).

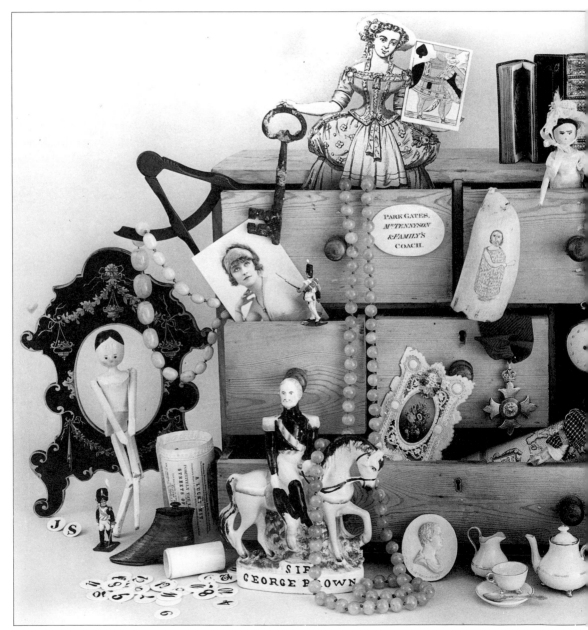

▶ CULINARY COMPOSITION

It is important to confine attention to the components making up the image. Take any of the elements out of this group and the sense of balance and harmony, of form and function, would be disturbed.

▼ PERIOD PIECE

In this arrangement, all the components come from earlier periods. Images of people predominate, looking as if they have burst out of the chest of drawers around which the composition is based.

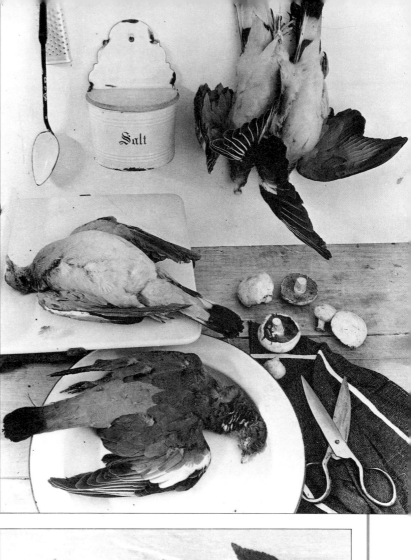

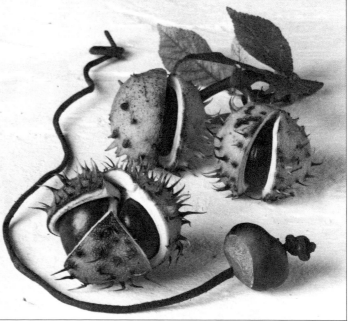

▲ AUTUMNAL THEME

The subjects here are the spiny cased nuts of the chestnut. One has been released and is threaded for a game of 'conkers', and the leather thong forms a boundary within which the other elements are confined.

43

Still life to tell a story

IF YOU HAVE A PARTICULAR interest in an historical character, then a little research might reveal a museum with a collection of interesting memorabilia that you could photograph. If you are lucky there may also be, as in the case of Robert Burns, who is the subject of these pictures, a national monument you could visit. Contacting one of the historical societies you will find listed in the telephone book, or the local tourist authority, is probably your best starting point for this type of information.

All of these pictures were taken at Robert Burns' birthplace, in a cottage in Alloway, near Ayr, in Scotland. As well as a still life showing a group of items used by Burns and likenesses of this great poet, there are also smaller groups showing certain objects in detail. To shoot these, it was necessary to obtain the permission of the curator and pay a small fee to have them moved into the best positions for the photography. And because the cottage remained open to the public throughout, it was not possible to set up artificial lights. This made it essential to visit the day before to discover the best time of day for natural daylight and also to see when the cottage was likely to be least used.

▼ PERSONAL INSIGHTS

Still lifes like these make it much easier to think of Burns as an actual person rather than just an historical personality. In this composition, manuscripts have been grouped together with personal items such as his pipe, and there is a silhouetted likeness propped up against a song book of Burns' preferred lyrics of Auld Lang Syne. These have been poignantly linked to the image of his shaving mirror and razor, which looks a little like the hands of a broken clock.

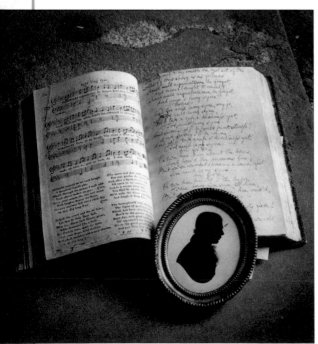

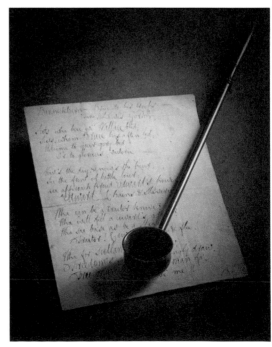

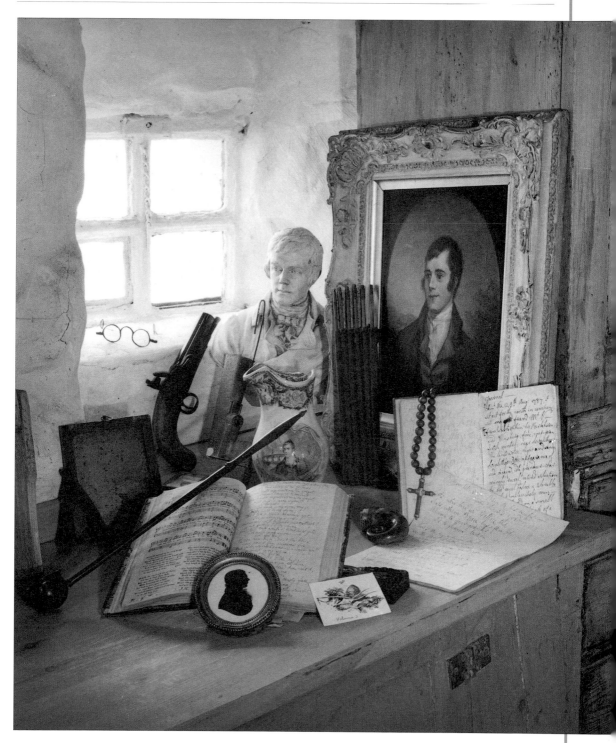

▲ **USING A TRIPOD**

Although it was not possible to use studio-type lighting in Burns' cottage, a tripod was permitted. Luckily, the old glass in the window behind was not of today's high standards and so it rather softened and diffused the overcast light as it passed through. This was enough, with the use of a fold-away gold-coloured reflector, to give a very satisfactory result with a 50mm lens set at f16 and a shutter speed of $1\frac{1}{2}$ seconds.

'Found' still lifes

NOT ALL STILL LIFE photographs are set up in the studio or on a table top (*see pp. 40–3*). If you take the time to look, you will find that your own home and the streets you walk down every day are full of still-life photo opportunities.

Some 'found' still-life studies result from our innate design sense – ornaments arranged on a shelf are an expression of our desire to make our surroundings more pleasant, for example, and such a group could make a perfect still-life picture. Other found still lifes occur through association of objects used in a particular task – an arrangement of utensils , for example, placed so that they come easily to hand when required. Shop windows are another source of images. You may, however, have only limited control over lighting and you will have to find the right angle to show your subject in isolation.

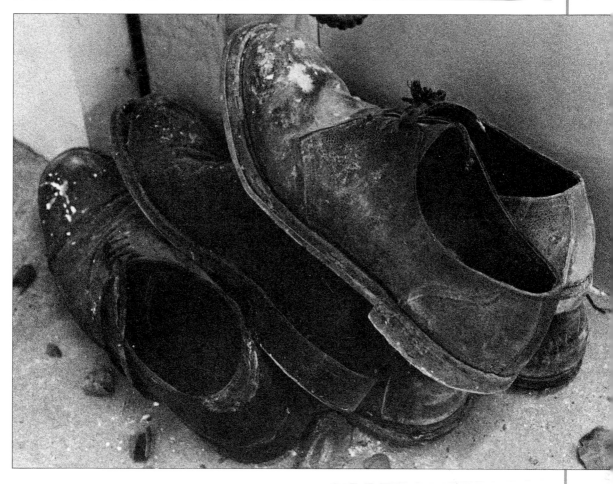

▲ GARDENING SHOES
Tucked against a wall near the back door, a pile of gardening shoes have been slipped off, some laces still tied, before their owners entered the house. When isolated by the camera like this, these ordinary objects make an ideal composition.

◀ WAIT FOR THE LIGHT
The simplicity of the objects making up this still life has an immediate appeal. When first seen, however, the light was frontal and any sense of texture was absent. Three hours later, the sun had moved around and dropped lower in the sky, and the character of the objects was totally transformed.

▶ REPEATING PATTERN
By tightly framing just a section of this neatly stacked pile of terra-cotta pipes, it was possible to create a still-life composition of rigid uniformity of shape and form.

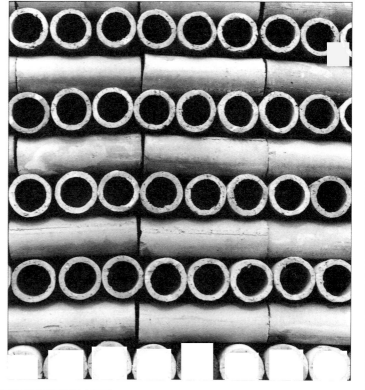

Sculpture as still life

PHOTOGRAPHING PIECES OF SCULPTURE of people requires an approach somewhere between portraiture (*see following chapter*) and the traditional still-life techniques covered in the preceding pages.

As in portraiture, the type of illumination that most often produces a satisfying result comes from angled lighting. This will show some subject planes fully lit and others in varying densities of shadow. The fact that you are working with a fixed subject allows you the luxury of time, however, which is something often missing when dealing with real people. Move right around your subject before shooting to find the best angle to record and the most telling lighting effect.

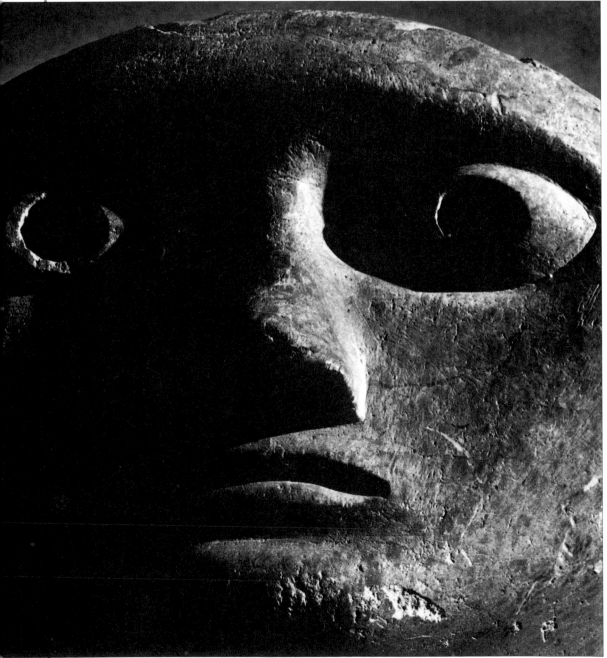

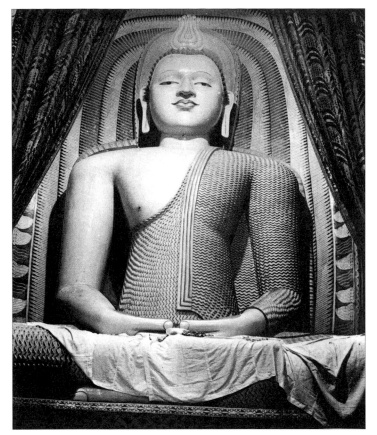

◀ CHARACTER LIGHTING
The serenity and openness that is traditionally associated with the character of Buddha has been reinforced here by the warm and natural light that seems to emanate from his statue. The slightly low camera angle also helps to imply his god-like status.

◀ DRAMATIC CLOSE-UP
As in portraiture, if the subject's face is strong and full of character, then you can move in close and use lighting that is contrasty and slightly more theatrical than usual. Here, the lighting is very directional and most of one half of the statue's face is in dense shadow.

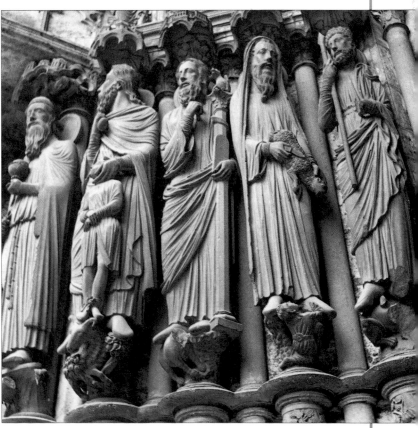

▶ GROUPS OF FIGURES
Lighting is critical when photographing a group of figures such as this. You need to ensure that each is recorded to best advantage, but you can't allow shadows cast by any one figure to obscure the vital parts of any other.

Portraits

Of all the areas of photographic interest, pictures of people – portraits – are the ones we most readily identify with. We study the subject's face, whether that person is known to us or not, trying to discern in the eyes, the set of the face, something of their inner thoughts, character, motivations. In a fuller-length portrait, in which the face is perhaps not shown in that much detail, we interpret the body language instead and look at the subject in relation to the other picture elements, again in an almost automatic attempt to try to understand something about that person.

Successful portrait photography is, therefore, concerned not only with the person who represents the main focus of attention of a picture, but also with all the other areas of the frame. Before taking any picture, look at all of the frame. Decide what you want to include or omit, adjust the lens focal length or the camera position and determine the most appropriate shutter speed and aperture. Then – only then – press the shutter release.

▶ CHARACTER CLOSE-UP
This arresting portrait of Welsh photographer Angus McBean shows very simply the flamboyance and ease of a man best known for the extravagance and originality of his own photographic style, which often involved the building of elaborate sets, double exposure and various montage effects.

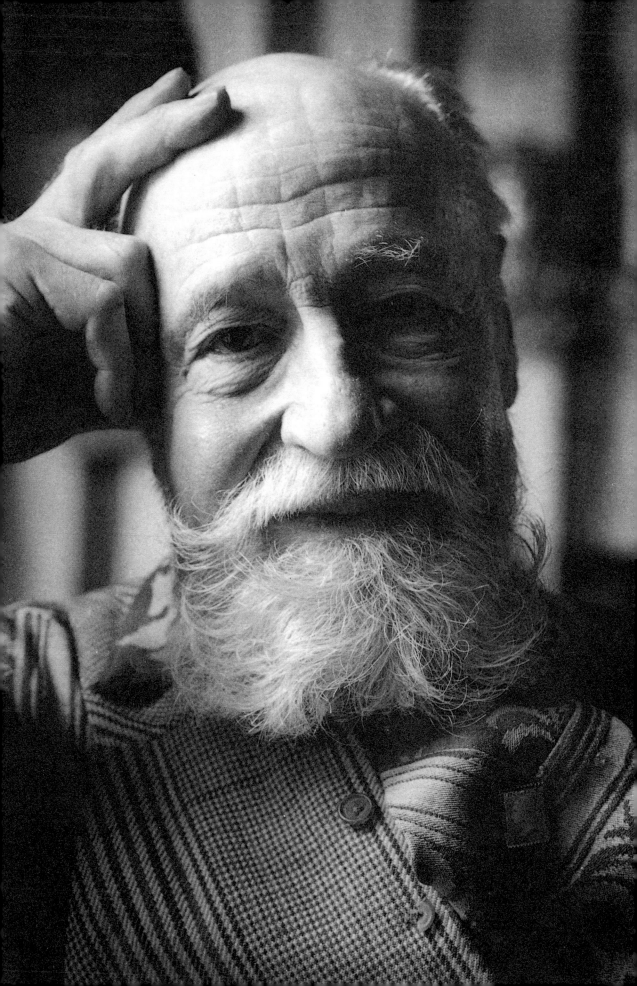

Capturing personality

THERE ARE MANY varied aspects of portrait photography – formal portraits, candids, children, nudes and glamour and so on – and each is concerned, primarily, with different facets of the subject. For any one of these types of portrait to be successful, however, the image has to communicate at some level with the viewer and, for this to happen, something of the subject's personality must be clearly recorded by the camera. This is the art of portrait photography.

Weighting the odds

You will greatly increase the chances of a successful portrait session if you build some sort of rapport with your subject. More than important, this is vital! Before the session

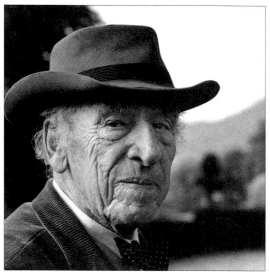

▲ SUBDUING A BACKGROUND

This series of photographs is of the architect Clough Williams-Ellis, builder of the Italianate fantasy village of Portmeirion on the coast of Wales. The village and its grounds were used as the setting, but in this shot, a long 135mm lens and an aperture of f4 ensure that the distant landscape is reduced to an impressionistic blur, which gives just sufficient information without taking attention away the rock-steady gaze and barely suppressed smile of the subject.

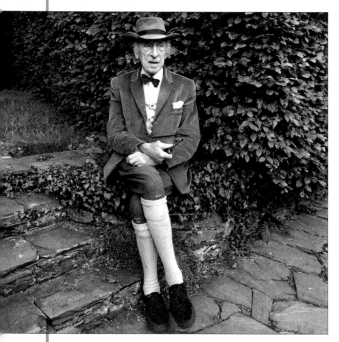

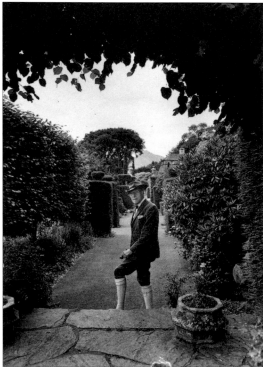

▲ CAMERA ANGLE

This slightly high camera angle looking down on the subject has caused some foreshortening, something that I used here to emphasize the precision and style that so characterizes every aspect of the subject's personality and appearance.

▶ THE GRAND TOUR

Asking the architect to show me around his creation was the perfect way of helping him to relax and enjoy the photo session. Here he pauses and turns, perfectly aligned between the shrubbery.

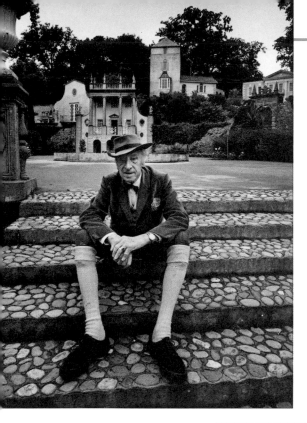

starts, find some common areas of interest, and continue talking to your subject while the session proceeds. Shoot lots of film, varying framing between close-ups and full-lengths, look for less-obvious shooting angles and make sure that the backgrounds contribute something positive to the images.

Working in black and white, you won't have to worry about the colour of the background or any other subject elements, but their tonal strength is an equally important consideration. So, too is their degree of sharpness or blur, controlled by focal length and aperture. If your subject is dressed in light-coloured clothes, for example, he or she may look better against a dark-toned setting. And if this setting forms an important part of the shot, make sure that it is sharp, or at least reasonably so. If it is not important, then knock it out of focus.

▲ SHOWING THE SETTING
In this shot of the architect Sir Clough Williams-Ellis I wanted to show him framed by some of the buildings and garden architecture of his creation, Portmeirion. To do this, I used a 28mm wide-angle lens and an aperture of f16 to give a generous depth of field. It is interesting to note the pipe he is holding. It appears in all shots in which his hands are visible, and he held it unconsciously all the time, like a prop, to help himself relax.

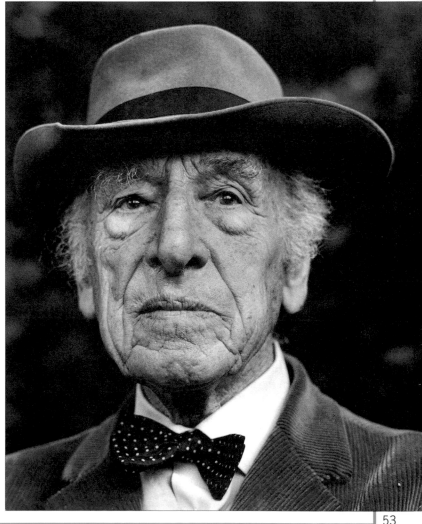

▶ FRAMING THE FACE
Character is always more obvious in a detailed close-up and the subtle tonal gradation in this photograph is the type of effect that attracts many people to the black and white medium. The light grey of his hat not only frames his head perfectly, but it also helps to separate him from the background, bringing the figure forward in the frame.

Using props

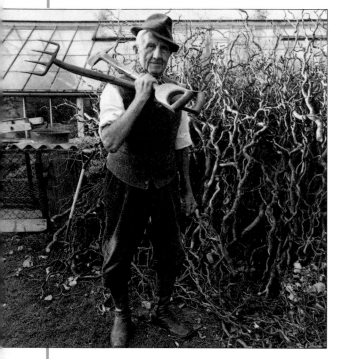

PHOTOGRAPHIC PROPS can enrich your portrait photographs. Often they are used by photographers to help add information about their subjects and so produce a more rounded, 'fleshed-out' portrait. This type of picture most often emerges when the subject is photographed where they work or live, and so the setting will be full of things relevant to what they do, their homes or how they spend their time.

If the subject of your portrait is ill at ease or uncomfortable about the presence of the camera, then props can come to your assistance simply by providing a focus for the subject's attention. Although the prop may, literally, be serving no purpose other than giving them 'something to do with their hands' (*see p. 53*), it still could be saying something about them in a more oblique fashion. Take care, however, since too much detail may be distracting and weaken the photograph's impact.

▲ GARDEN PROP
The spade and fork slung over the shoulder of this old gentleman are rather obvious props but they help to give a proper context to the subject. Other areas of the frame – such as the glass house in the background and the massive pile of pruned branches stacked just behind him, their contorted shapes echoing his bent legs and back – reinforce this.

▶ PORTRAITS WITHIN PORTRAITS
This photograph of an artist at work in the tiled and rather grand surroundings of his studio is full of detail and interest. The fact that canvases of painted portraits are on view all around makes it a complex image, but the paint box and brushes in his hands leave us in no doubt as to the true subject of the picture.

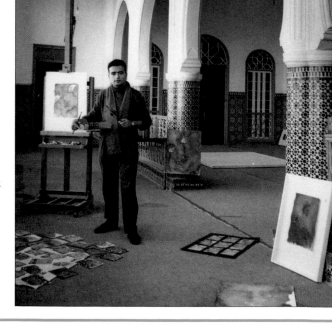

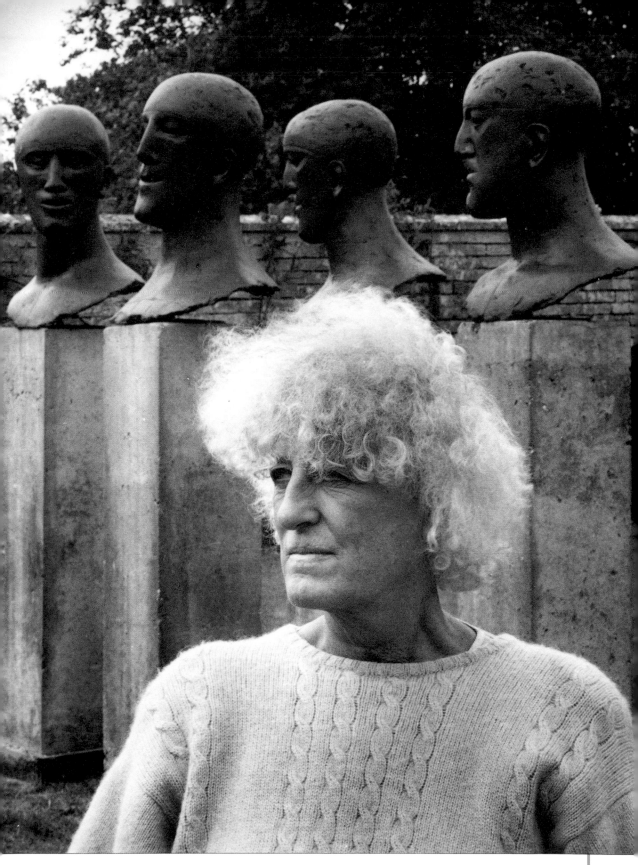

▲ INCIDENTAL PROPS

In this portrait of sculptor Elizabeth Frink we see her in the garden of her studio. The photograph is framed so that approximately half the image is taken up with a row of her sculpted heads set on tall concrete pedestals. It is the position of the head on the far left, however, which is most significant. It seems to be staring directly at its creator, thus fixing attention where it is intended.

Choosing a background

RATHER THAN BEING a neutral backcloth to the main action, like the poorly painted canvas sheets seen at old-fashioned vaudeville shows, the background to a picture demands as much care and attention as any other area of the frame.

Backgrounds are most often thought of as acting in some sort of subsidiary role in a photograph, as that part of the picture area against which you view the main subject. In the shots on these pages, however, you can

see that the backgrounds have in fact been fully integrated and they are as vital a part of the subject matter as any other element, producing a richness and visual complexity that is compelling.

▼ **FANTASY FEMMES**
Perched on top of a drum of industrial-strength hand cleaner, this motor mechanic strikes a rather clichéd figure surrounded by the tools of his trade and by an array of girlie posters on the wall behind.

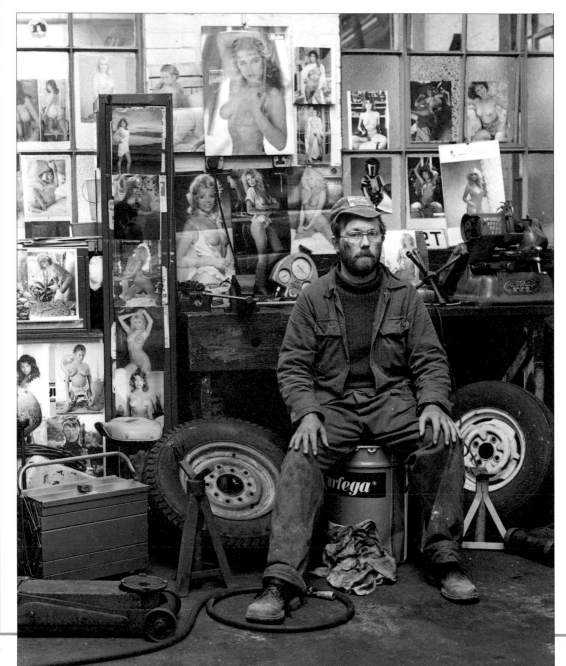

► **STRESSING THE BACKGROUND**
In this photograph, taken in a back-street in a poor quarter of Rome, nearly all the visual information is contained within a single plane – the background. Even the figure of the young woman leaning in the doorway has become simply another background element.

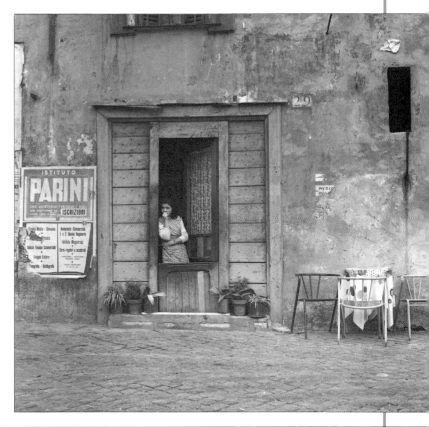

▼ **CAMERA ANGLE**
This picture was taken from a high camera angle, looking down on the subject. As a result, the figure is seen surrounded by tall crops. The tonal uniformity of the scene, consisting entirely of lighter shades of grey and white, produces an image dominated by shape and repeating pattern.

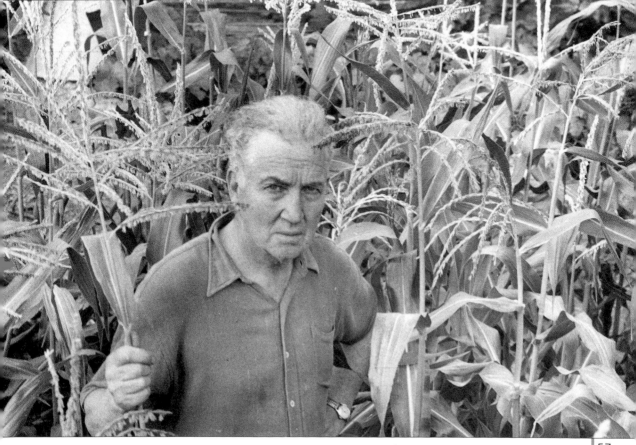

Working around the subject

A WELL-ROUNDED IMPRESSION of your subject is more likely to result if you can arrange to spend a few hours or half a day with them, photographing them and their activities from many different angles. If you have the opportunity to do this, try to visit the location for the portrait session beforehand so that you can see the type of lighting you will be working with, and perhaps determine at what time of day the sun is likely to be most favourable.

Maintaining interest

If you intend to put together a portfolio of photographs of your subject, it is important to have plenty of variety in order to maintain interest. Make sure that you vary shooting angles and also try to produce a range of different image framings – such as detailed close-ups, half-length and full-length shots – as well as pictures that show both the subject and his or her environment.

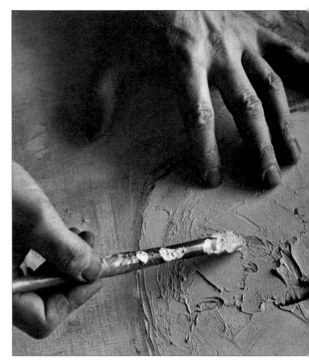

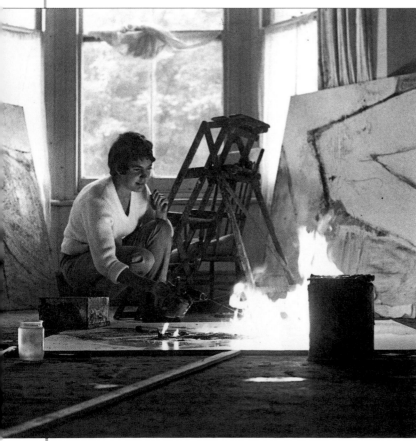

ARTIST AT WORK
This portfolio of photographs was taken in one afternoon at the studio of artist Sandra Blow. The north-facing room was full of light yet it did not receive much direct sunlight. This made it possible for me to change my camera position frequently without contrast becoming a problem – which is often the case when relying on window light.

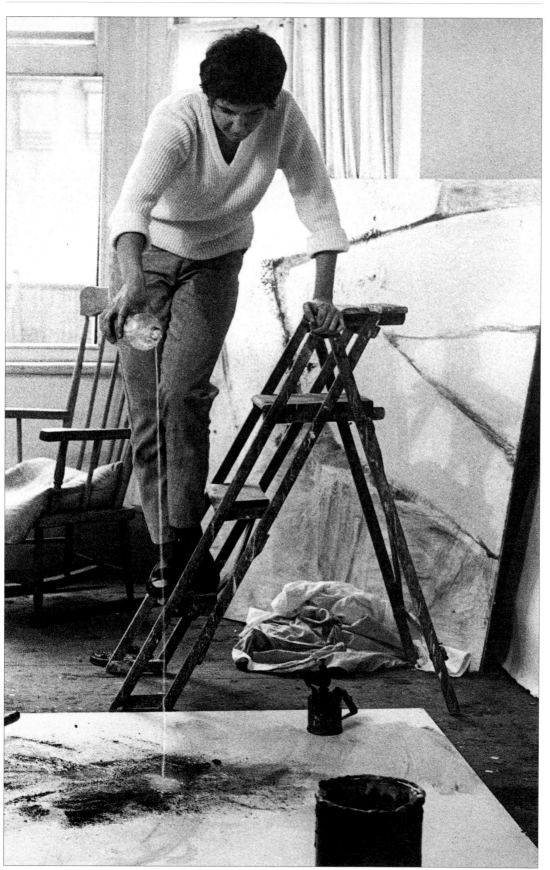

Using the environment

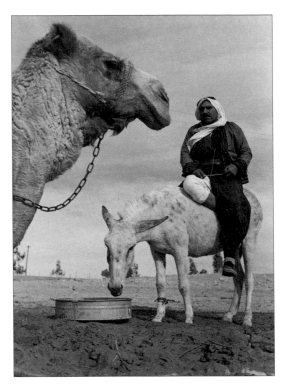

A MISTAKE MANY PHOTOGRAPHERS make is to concentrate so much of their attention on what they know to be the main subject of the picture that they fail to take account of the environment in which that subject will appear. Rather than being merely extraneous clutter, the environment in which you choose to show your subject is often what makes the picture interesting or unique.

Different ways of seeing

It does take some practice to be able to see in your mind's eye the way the subject and setting will relate to each other in a photograph. For a start, when you look at any scene your eyes constantly flick and dart as your attention is first caught by one thing, and then another. In this way you build up a complex, yet piecemeal, impression in which some things are clearly defined while others – those that didn't interest you – are largely ignored and therefore suppressed. The camera, however, is not capable of making

▲ LEADING THE EYE
With the largely arid flatness of the a desert environment to contend with, you need to look for other subject elements to bring into play. Here, the camera position was intentionally selected to include the neck and head of the camel in the foreground. Not only does it lead your eye directly to the dark-clothed figure perched casually on the donkey's back, but also the difference in scale between the camel and man introduces a note of humour.

▶ ATMOSPHERIC BLUR
This poorly lit indoor setting meant using a shutter speed too slow to freeze the movement of the potter's assistant, whose job it is to turn the wheel by hand. The neatly stacked pots between the women's heads are the fruits of their labour and the camera angle is sufficiently wide to show the primitive conditions in which they have to work.

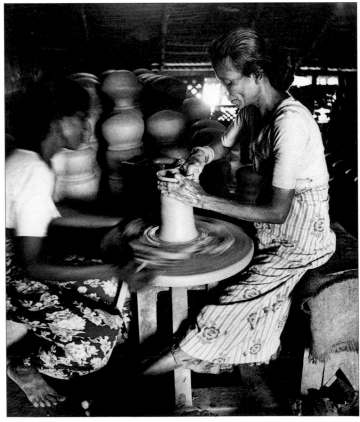

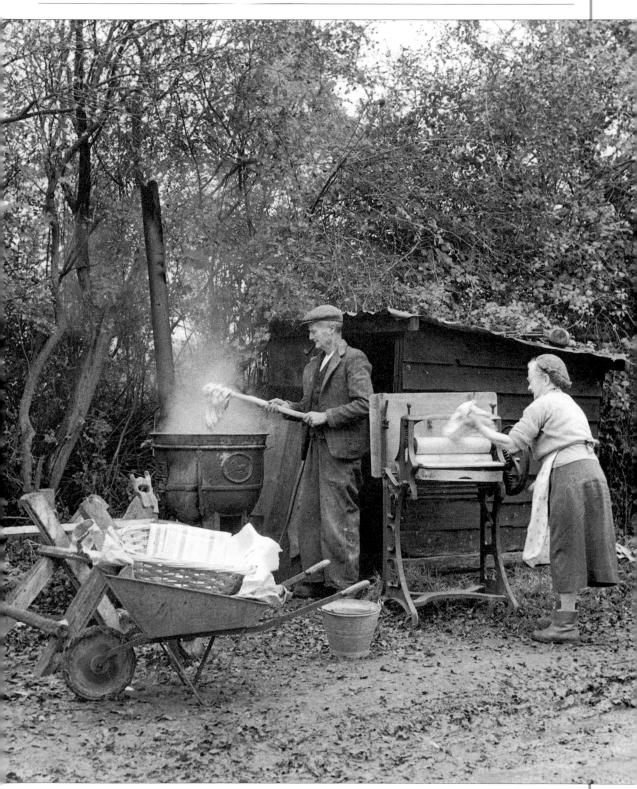

▲ WASH DAY

This elderly couple lived all their lives happily on the land, enduring conditions that most city folk would find intolerable. The use of black and white film has increased that feeling of looking back in time and every part of the scene provides a wealth of information about a lifestyle that has largely ceased to exist – a wood-burning boiler with its sooty chimney stack, wicker clothes basket, hand-operated mangle.

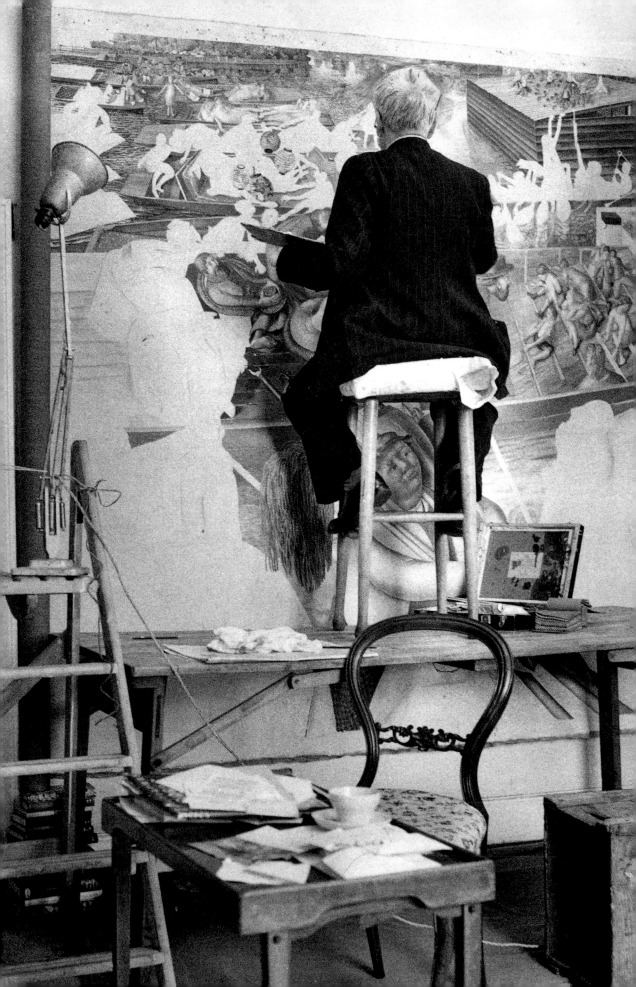

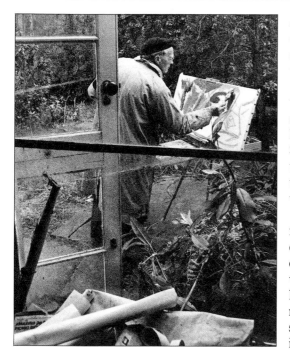

such sophisticated distinctions and, consequently, gives all subject elements much the same prominence – unless, of course, you take a hand.

The most effective way of previsualizing the finished photograph is to look at the scene through the camera's viewfinder. The hard edges of the viewfinder, especially of an SLR camera, completely exclude detail other than that which will appear within the picture area. This is very different from the way you normally see a scene.

With the camera to your eye, look at all four edges of the frame and see how even quite small shifts to the left or right, up or down, bring new elements into the scene, while others slide out of view. Adopting a low camera angle and shooting upward minimizes a less-than-attractive foreground, and shooting down from a high angle lessens the intrusion of more distant subject elements.

▲ REPEATED SHAPES
This garden environment is an ideal setting for the English painter Ivon Hitchens, who is best known for his semi-abstract interpretations of broad landscape scenes. The edges of the door and the glazing bar seem almost to act as frames, echoing the strongly horizontal shape of the canvas.

◄ PRECARIOUS BALANCE
The rather eccentric portrait of artist Sir Stanley Spencer perched precariously on a high stool while working on a large canvas tells us much about this artist's environment and method of working.

► CREATIVE CONFUSION
Sculptor Eduardo Paolozzi appears here to need the help of a stepladder in order to raise himself above the clutter and confusion of his studio. Although obviously a candid portrait, the camera angle has cleverly picked out the only path through the sculpted figures and found a relatively clear area of floor leading to the subject himself.

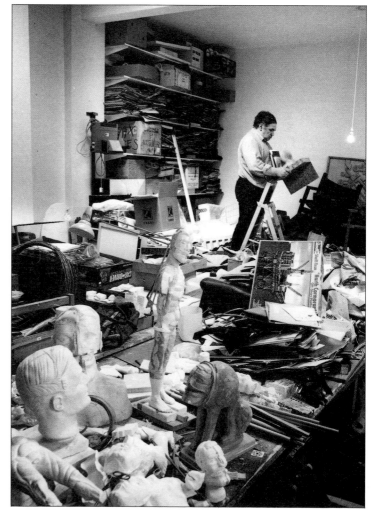

People at work

WHEN PEOPLE ARE AT WORK, and occupied with their routines and duties, they are likely to forget, or at least ignore, the presence of the camera. This can work to your advantage, giving you the chance to capture relaxed and informal candid pictures.

If you know the type of area you will be shooting in – the amount of space available to move around in and likely light levels – you will then know what range of lenses to have to hand and the speed of film required. For example, in a large room you will need a long lens to grab a spontaneous close-up of somebody at the far end of the room without having to change camera positions.

▶ **SPACE-AGE CLOSE-UP**
The shots on these pages, and the two that follow, were all taken in a foundry. This first image of one of the foundry hands in full protective clothing and mask looks as if it comes from the set of a sci-fi movie.

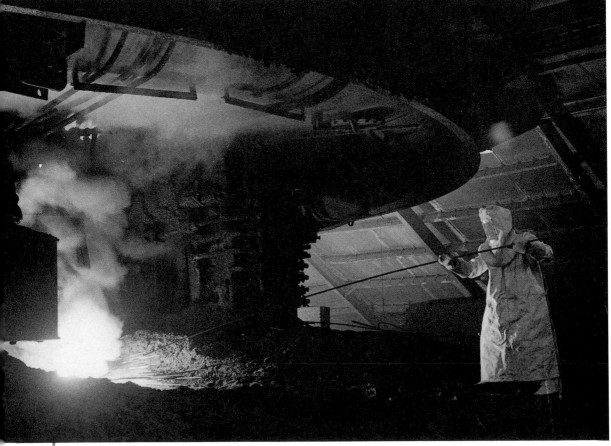

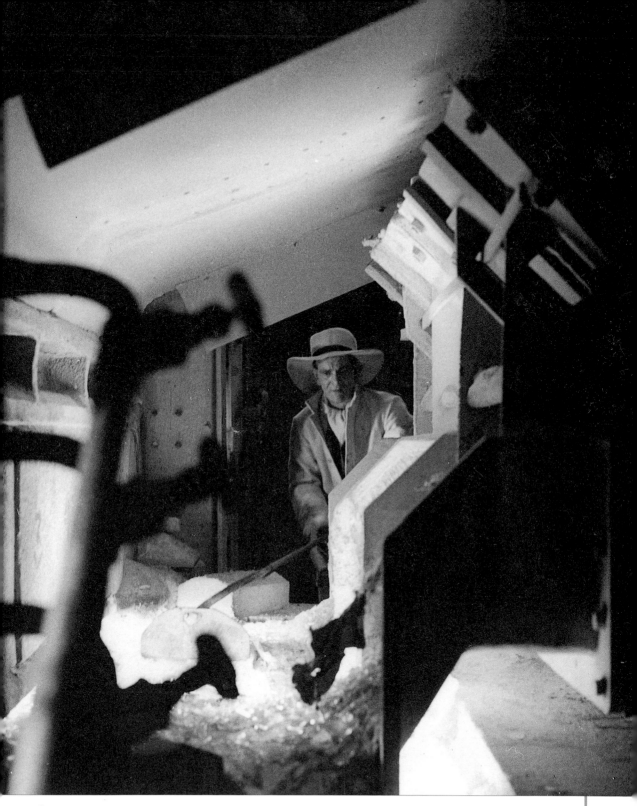

◄ SHOWING THE ENVIRONMENT

Shots taken with a long lens are great for details, but the foundry environment I was shooting in was so dramatic that the only way to give a true indication of the place was to switch to a wide-angle lens for some of the pictures. Here we see the fully protected foundryman using a long rod to clear the channel along which the molten metal will run. The light being thrown out by the furnace was so intense that it illuminated the rest of the room.

▲ LOOK FOR FRAMES

Frames (*see pp. 28–9*) can be used, as here, to help give a focus of attention to a photograph. By using some of the machinery as a frame for the subject I was also able to show interesting aspects of the workplace.

▲ FIND THE RIGHT ANGLES AND POSITIONS
Contrast at the foundry proved to be my biggest problem. The room was a mixture of intensely lit spaces, adjacent to the furnaces themselves, and areas of relatively dense shadow. It was impossible to set an exposure that accommodated both lighting levels, so shot by shot I had to decide on either a highlight or a shadow exposure reading. The reading for this image was taken from the workman's apron.

▶ SILHOUETTE
This dramatic scene shows one of the workmen on a high walkway with the molten metal flowing beneath him. By taking a light reading from the brightest area of the frame the foreground figure has been shown as a dark silhouette. Note how the intensity of the light is so great that it has 'eaten' away part of his shape, especially in the area of his arm.

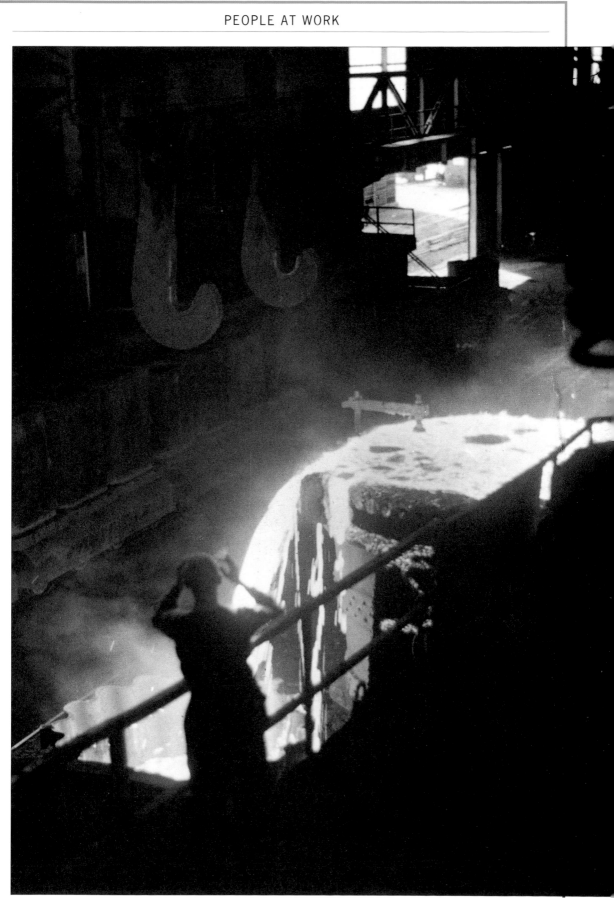

Informal portraits

Portraits taken when the subject is relaxed and off-guard can be most revealing. The trick here is either to draw your subject out, so that he or she starts to act naturally in front of the camera, or to go for a candid type of approach, where the subject is totally unaware of the camera's presence.

With either approach a telephoto is the most generally useful lens to use. If you are trying for candid shots, you will usually want as much distance between yourself and the subject as possible, without sacrificing too much in terms of image size. Use a lens of about 135mm, as long as its maximum aperture will allow you to use shutter speeds that don't require a tripod!

Even if your subject is a willing participant, you will need to get uncomfortably close in order to fill the frame with just the head and shoulders using anything less than a 90mm lens. With a shorter lens, pull back a little and enlarge the relevant part of the negative later (*see pp. 138–9*).

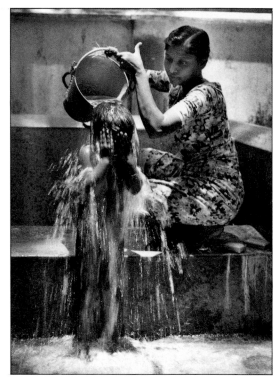

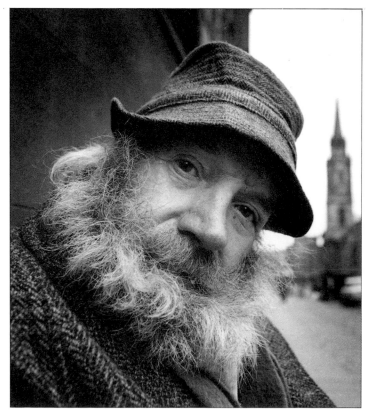

▲ **FIND A LOCATION**
One approach to candid photography is to find a likely location, such as the public bath house in this shot taken in India, and wait for the subjects to come to you. I had already prefocused the lens and set the exposure before the mother and son even entered. All that was necessary was to bring the camera up quickly and shoot when I judged the time to be right.

◀ **STREET LOCATION**
In portraiture, unless the background makes a positive contribution, try to minimize its impact. In this street portrait, I used a 100mm lens to restrict the angle of view and an aperture of f5.6 to ensure that the background was unsharp.

▶ **STUDIO LOCATION**
This portrait of the English novelist J B Priestley was taken during a break in a portrait session. He was off-guard and not expecting me to turn and shoot, and therefore he looks very relaxed.

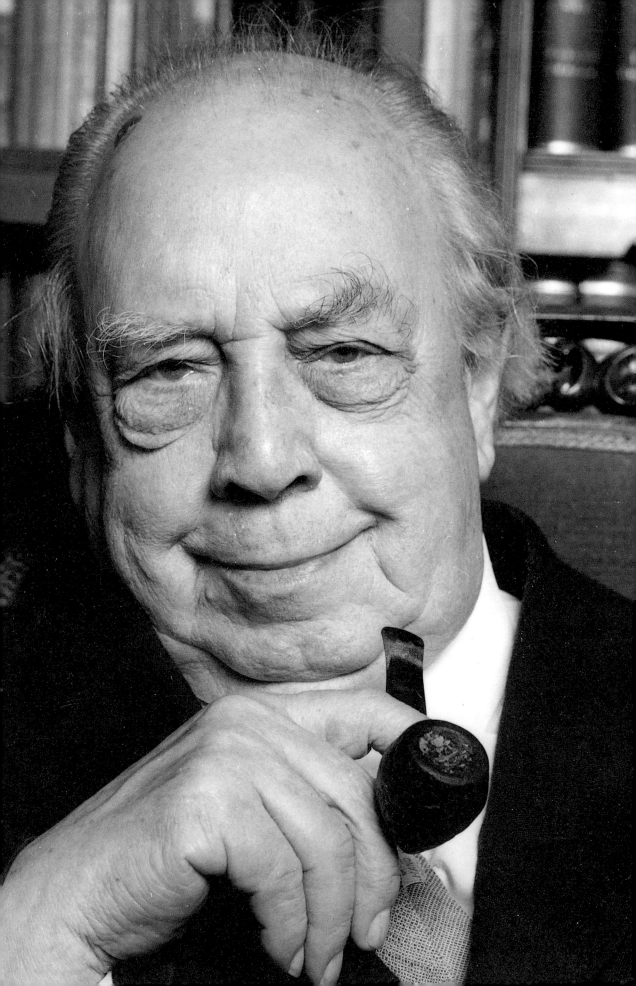

Arranged portraiture

IF YOU ARE AN ENTHUSIASTIC photographer, you may sometimes be asked to take pictures of friends or acquaintances. If so, take these opportunities to increase your formal skills, as well as your confidence in handling an arranged portrait session.

Find out from your subject his or her exact requirements, the number of pictures wanted, the style of portrait – formal or informal, studio or location – and agree with them a place, time and perhaps a fee to cover any out-of-pocket expenses for travel, film, processing and printing.

Think carefully about the setting and what precisely the pictures should convey – expressions, poses, mood and atmosphere. And if you will be shooting at a location you are not familiar with, visit it in advance to check if you will need additional lighting equipment, extension leads and so on.

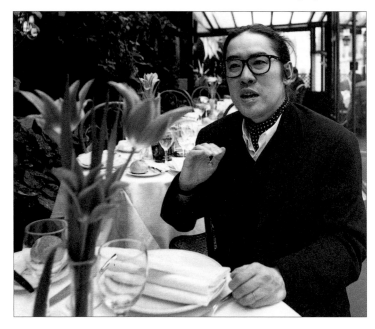

CONDUCTING THE SHOOT
Once you have a good idea of the type of pictures your subject wants, you can then think about how you will conduct the portrait session. If it is to be a long shoot, suggest your subject brings along a change of clothes to give some variety. If possible, use a camera fitted with a motor drive or autowind. Then you will not miss out on a good expression or characteristic pose because you have looked away to wind the film on. Expect the first few shots to be a bit awkward, but as the session progresses your subject should become more relaxed and accepting of the camera.

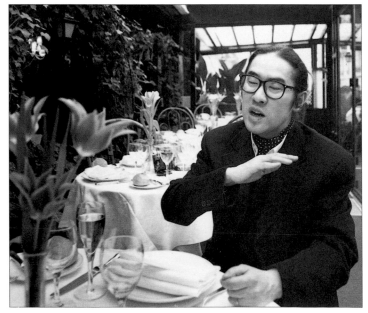

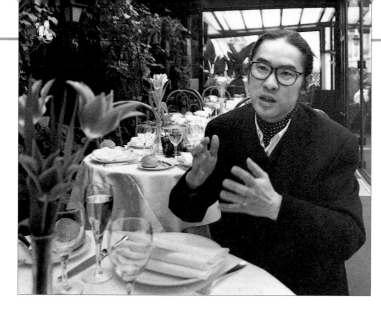

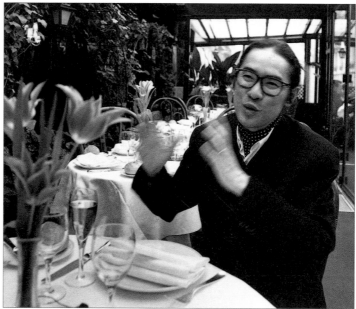

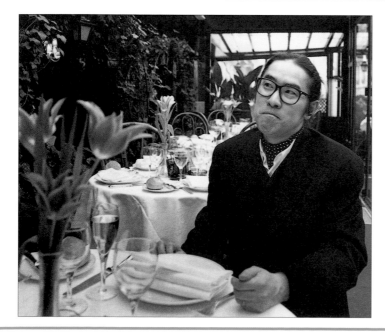

Babies and children

CHILDREN CHANGE SO RAPIDLY – from babies to toddlers and then toddlers to teenagers. Without the camera to record our memories, so much would become hazy over the years.

The occasional formal portrait might be good for recognition but a more relaxed, candid approach to pictures of children often produces the best results, showing character as well as a likeness. Children's moods fluctuate wildly, however, so stay alert to any photo opportunities and don't concentrate only on 'happy snaps' – the sad moments can be just as telling.

In terms of film, you need to strike a balance between a fine-grain response, which is usually best for child portraits, and enough speed for a fast shutter speeds even at full aperture – say, something around ISO 400.

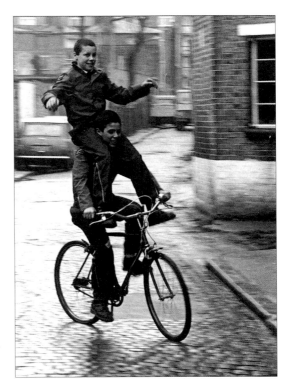

▶ **PLAYING TO THE CAMERA**
A shutter speed of 1/125 sec produces just enough blur to separate these daredevil stunt riders from a slightly streaky background.

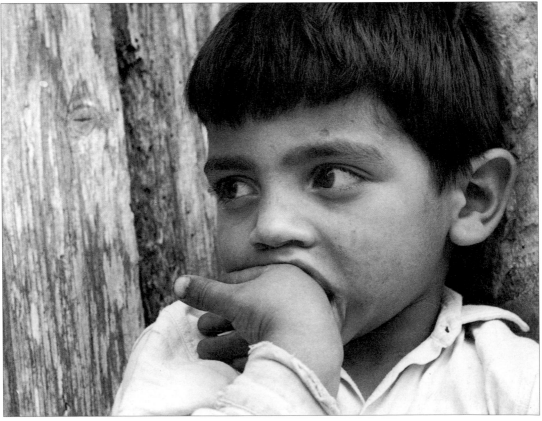

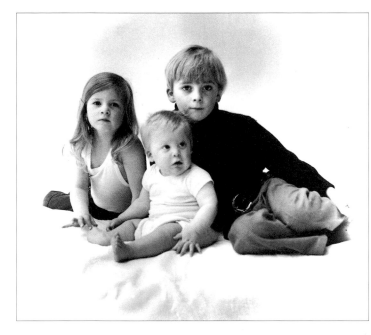

◀ FORMAL PORTRAIT
This charming portrait shows three children from the same family, and the high-key lighting approach is perfect for their young, fresh faces and blond hair. During printing, the centre of the negative, containing the image of the children, was printed through a circular hole in a piece of cardboard. This prevented light from the enlarger reaching the outside parts of the paper, which show up as white after development (*see p. 140*).

▶ CAREFUL COMPOSITION
It is often careful attention to detail that makes or breaks a photograph. This young baby was propped up on a magnificent carved wooden chair directly beneath the portrait of one of her ancestors. Note how your attention is first drawn to the baby, then up to the similarly toned white marble statue, whose head takes your eyes up to the portrait and then around to the small bronze figure on the right, whose gaze directs you back once more to the principal subject.

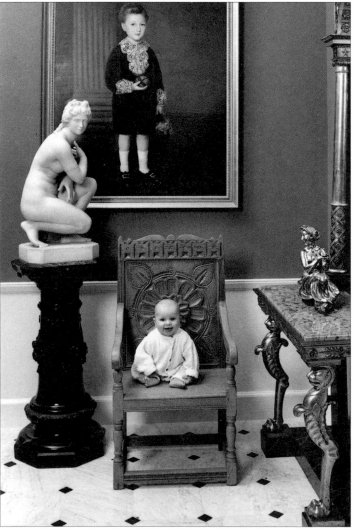

◀ LONG LENS
Lost in his own thoughts, this boy was photographed with a 250mm lens. If you are careful, a telephoto of this focal length allows a detailed close-up without the subject ever being aware of your presence.

Hands and feet

APART FROM THE FACE, hands are probably the most informative and expressive parts of the body. Hand movements and gestures, the way they are held when relaxed or excited, are a vital part of the communication process, and it is interesting to note that they are very rarely completely still.

An unusual portrait approach is to concentrate on the hands or feet of your subject. If you are taking the photographs on your own behalf, then there is no overriding reason to produce pictures that are instantly recognizable as being of a particular person, and people's hands and feet can often be very revealing of character and lifestyle.

The way we conduct our lives may also often be evident in our hands – the condition of the skin and nails, lines, creases and folds. When seen up close, people's hands can seem like contour maps of their lives.

Feet are a neglected part of the anatomy. For the most part encased in socks or shoes, once revealed and isolated by the camera they can make fascinating abstract subjects.

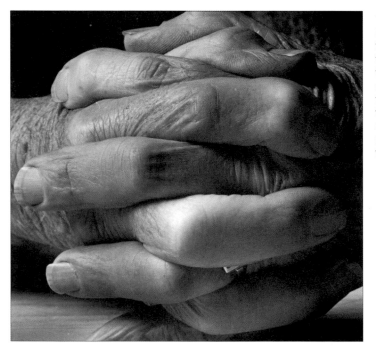

◀ **LENSES AND LIGHTING**
For a close-up like this, it is best to take a camera position back from the subject and then use a long lens to bring the hands up to full-frame size. If you move in too close with the camera, it makes positioning the lighting that much more difficult, since either you or your equipment may cast unwanted shadows over the subject.

▶ **ABSTRACT IMAGES**
The very tight framing of this photograph has effectively isolated the subject's feet. When seen like this, stacked on top of each other, they take on a rather sculptural quality and appear almost as abstract images. The lighting was directional to ensure that there were areas of shadow to contrast with the brighter, highlit parts.

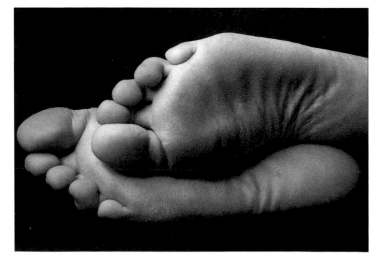

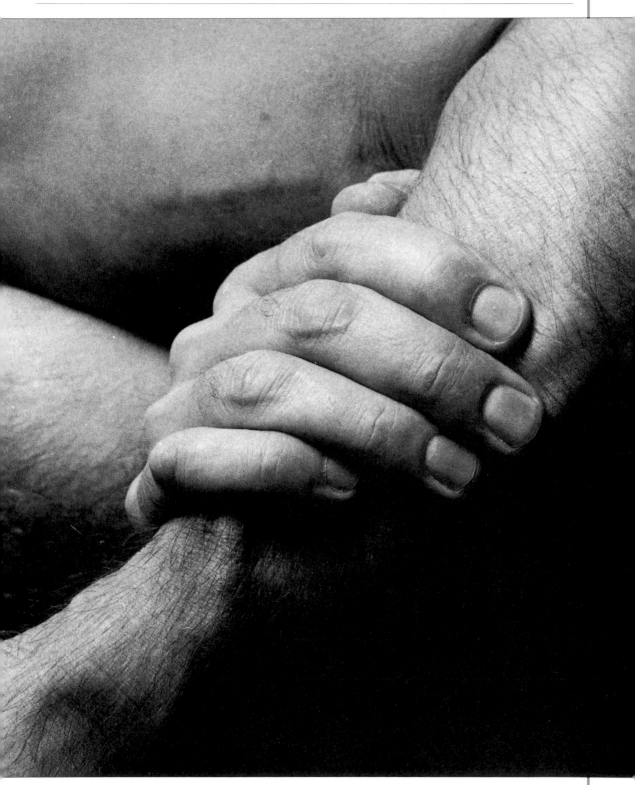

▲ **DEPTH OF FIELD**

Hands are very revealing – compare those of a manual worker, for example, with those of an artist and you can see their different histories laid before you. The hand of this subject has not been framed to isolate it physically from the rest of his body. Instead, the lens was focused on his hand and then a lens aperture selected that would ensure that the more distant parts of his body would be recorded only as a much softened, out-of-focus background that would provide interest without actually competing for attention.

The male nude

JUST AS THE tonal range of black and white film can be used to good effect to express the rounded forms and fine-textured qualities of the female form (*see pp. 78–9*), so too can it be used with equal success to show the power and grace of the male body – an often neglected aspect of nude photography.

Lighting

The best principal light source for the human figure is undoubtedly diffused side-lighting – from a window, flash or tungsten units, or a combination of any of these. One of the attributes of sidelighting in portraiture is that it accentuates the skin texture of your subject and, with a male subject, this will help to emphasize the coarser skin texture that is associated with male as compared with female subjects. Pictures of the male nude also often benefit from higher levels of contrast than you would normally associate with photographs of femal nudes, so you may find that your lighting scheme is simplified, since there is less need for fill-in lighting and reflectors.

Directing your subject to adopt the right pose will help to show particular muscle groups in his body. By using the right lens and framing, you can then isolate these to create fascinating semi-abstract images.

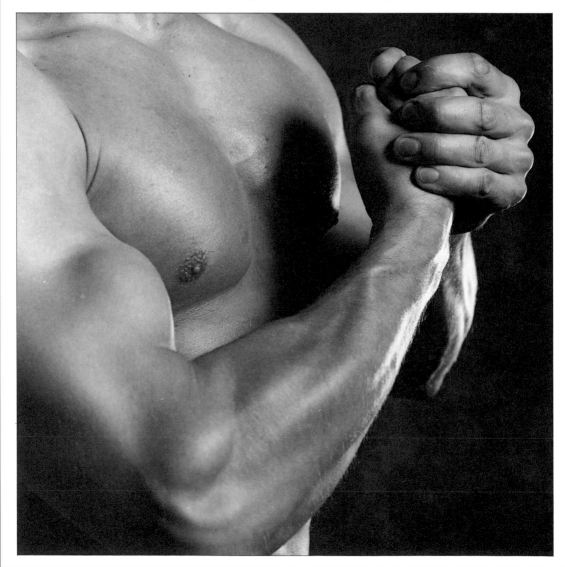

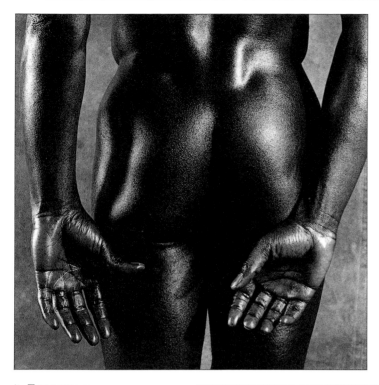

◀ CROPPING FOR EMPHASIS
Using a long lens or zoom setting will isolate part of the subject's body. The detail here shows the well-developed muscle groups in the small of this model's back and buttocks. These features have been emphasized by the use of body oil, which increase the tonal contrast between the high spots and hollows. Note, too, the obvious skin texture resulting from the use of very directional sidelighting.

▶ THE RIGHT POSE
For this shot I asked the subject to clasp his hands behind his head in order to set up the right muscle tension in his upper arms, shoulders and back. At the last second I also asked him to shift his weight slightly on to his right leg. This made the pose look more relaxed and natural and it also created that interesting fold of skin and muscle on the right-hand side of his waist.

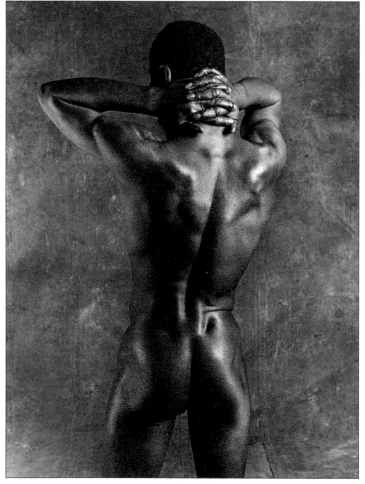

◀ USING FILL-IN LIGHT
This picture reveals a softer approach to lighting. Although the main light is still sidelighting, positioned on the far side of the subject shining at about 45°, some frontal light has also been added to reduce contrast. The power of his figure is still much evident, but his form looks predominantly rounded, and there is a softer more yielding quality to his figure in marked contrast to his tightly clenched hands.

The human form

DEPENDING ON HOW you light and pose your model, photographs of nudes can take on a clinical explicitness or concentrate more on such qualities as form, texture, shape and pattern, or more atmospheric and expressive photographs that include the setting, too.

Lighting effects

Unless you have access to a studio, the most readily available light source is daylight. And because of the obvious difficulties of privacy involved in photographing a nude outside on location, you will probably be restricted to an indoor setting, using window light.

The directional qualities of window light, which often create problems of excessive contrast in normal portraiture, can work in

your favour when dealing with the human form. Pockets of shadow, in which detail is completely lacking, may help to produce a more abstract result, especially if you move in close, use a long lens, or crop the image during printing (*see pp.138–9*) to exclude parts of the figure.

If, however, you want a more tonally consistent result, you can always introduce a reflector, flash lighting or, indeed, domestic tungsten room lighting – perhaps from an adjustable desk lamp – in order to reduce contrast in selected parts of the subject. Another way of creating a more generalized, softer type of light is to cover the window with net curtains or tracing paper to diffuse and spread the light entering the room.

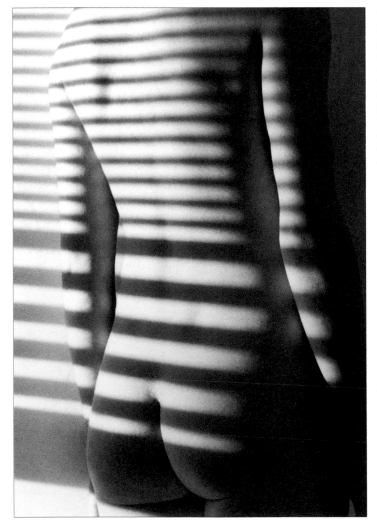

◀ WINDOW LIGHT
Posing the model against the wall gives a neutral backdrop to this shot. The pattern of light and shade, cast by the slats of the venetian blinds over the window, creates a strongly abstract image in which sexuality is suppressed in favour of pattern. This abstract quality is emphasized by the tight cropping of the subject, which excludes her head and legs.

▶ EMPHASIZING SHAPE
The use of a wide-angle lens positioned close in has elongated the apparent length of the model's arm. As well, photographic tungsten light angled so that her head is swallowed up in deep shadow, and the pose showing her body folded over on itself, all combine to produce a composition in which shape is the principal feature.

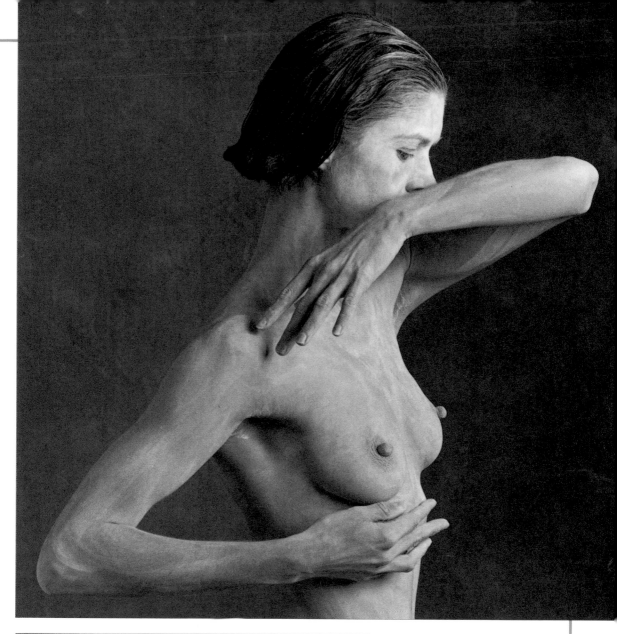

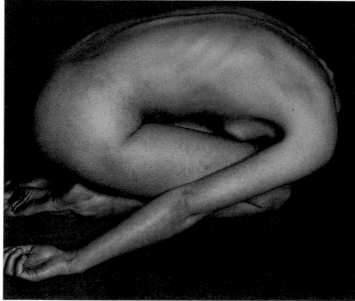

▲ MAXIMIZING POTENTIAL

It is often a mistake to start a photographic session with too rigid an expectation of what you want to achieve. The physique of this model largely dictated the way the session progressed, with the poses, lighting arrangements and body make-up all determined by her angularity and sinuousness. Although the pose here is very static, the diagonal line formed by the positions of her arms imparts a powerful sense of movement, and the obvious tension evident in her body makes it seem as if she could burst into movement at any moment.

Abstracting the nude

MOVING IN VERY CLOSE to the subject, in order to fill the frame with isolated parts of the anatomy, can turn the human body into a landscape of pictorial possibilities.

Lighting a detail, such as those you can see on these pages, is not dissimilar to that required for a full figure. The main characteristics you will probably want to emphasize are outline shape, form and surface qualities, and the best place to position your lights to achieve this is somewhere on an arc starting with the light virtually parallel to the subject, giving a racking effect, to about three-quarters on.

To help you plan your composition, use the camera's viewfinder constantly to check exactly the view as seen by the lens. When looking directly at your subject, your eyes take in too much of the surrounding detail that will not form part of the final picture.

► **REPEATING SHAPES**
In this close-up, the camera angle and lighting have isolated the subject's buttocks. The perfect symmetry of the repeating curves is strengthened by a light set to just graze the topmost surfaces, providing a contrast with the deep shadow between.

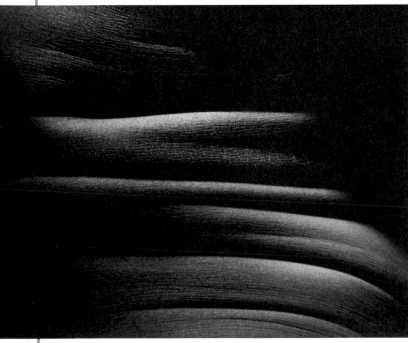

◄ **SEASCAPE**
Looking like the gently undulating surface of a moonlit seascape, this intriguing close-up shows an isolated part of the abdomen, with the skin pushed into tight folds by the subject's pose.

► **OPPORTUNITY STRIKES**
The opportunity for this picture occurred on a coffee break during a normal shoot, when I noticed the male model I was using absent-mindedly massaging the skin on his upper chest with his thumb.

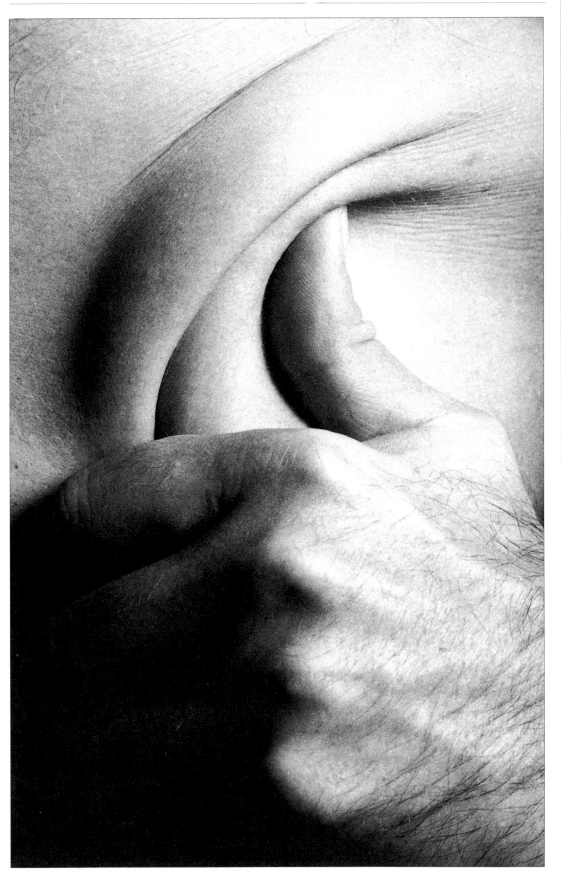

Nudes – natural light

MOST PHOTOGRAPHERS who might like to try their skill at photographing the human form immediately think of using a studio. The advantages of a studio are two-fold: first, you have complete control over lighting and, second, you have privacy.

However, although less controllable, natural daylight has one overwhelming advantage over studio lighting – it is unpredictable and therefore capable of producing many different moods and subtle shifts in atmosphere.

In a completely private outdoor location, you will be able to benefit from a full repertoire, as the sun moves from the gentle light of morning through to its fiery conclusion at dusk. Indoors, a room receiving indirect light gives fewer contrast problems, but contrast is not something necessarily to avoid.

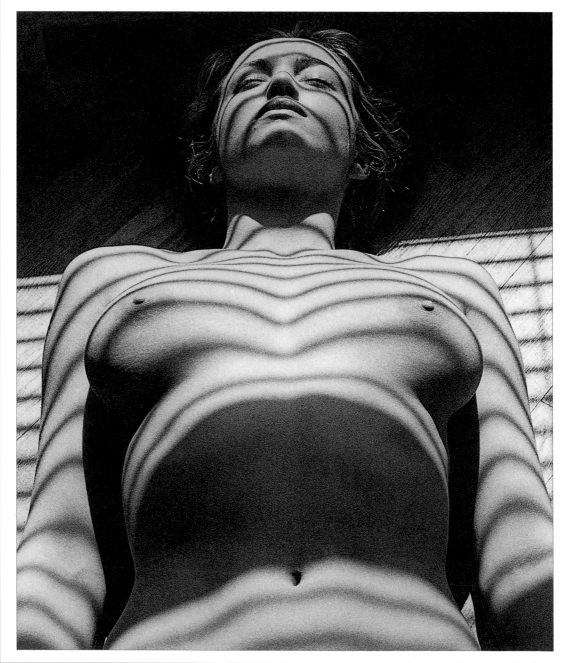

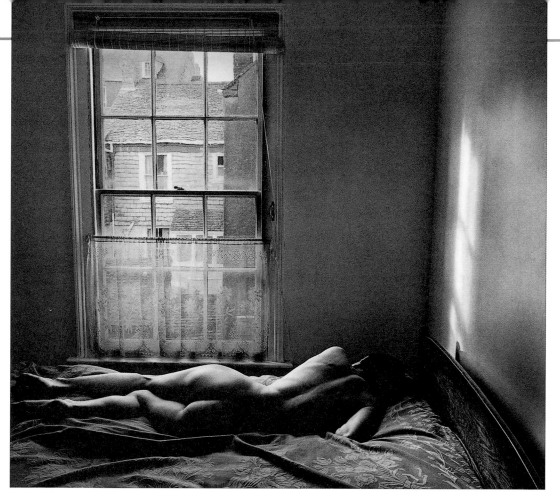

▲ DIFFUSED WINDOW LIGHT
The lace curtain softening and
diffusing the light entering this
small room produces an intimate,
private type of scene, an effect that
is very much in keeping with the
subject, setting and pose.

▶ DAPPLED SUNLIGHT
Sunlight filtering down through the
tree canopy to a fern-covered
clearing in the woods produced a
secluded and intimate setting for
this study of the human form. The
light, although dappled, is generally
quite bright throughout the scene,
and the range of contrasts is well
within the capabilities of the film to
record successfully.

◀ UNDIFFUSED WINDOW LIGHT
Here, the human form has become
integrated with the pattern of
reflections cast across the
subject's body. Harsh, undiffused
sunlight streaming in through the
window has thrown a sharp, hard-
edged image of the open venetian
blinds into the room.

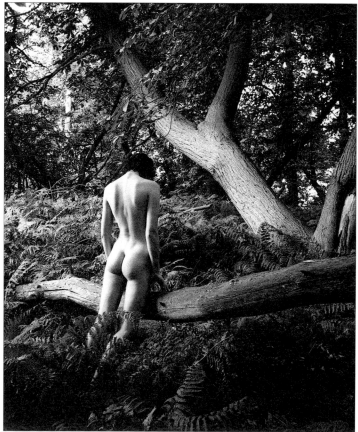

Studio lighting

Don't be put off when you hear the word 'studio', thinking that you need a professional kit of expensive lights and masses of space. Even a small spare room can be used as a temporary studio. For lighting you can rely solely on daylight, or a mixture of daylight, a flashgun, ordinary domestic lights such as adjustable desklights, and a few cardboard reflectors.

If you do have more space available, such as you would find in an average garage, then you can be more adventurous with your lighting schemes, introducing more sidelighting, for example, and toplighting, both of which require a free space around your subject.

Even if you don't like the formality of a studio setting, it is the place to learn most about how to control and create lighting effects, lessons that you can then apply to all of your photography – indoors and out.

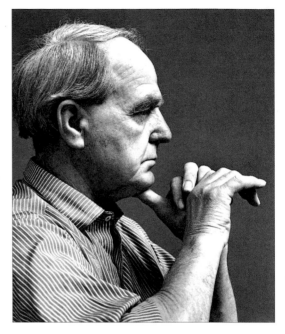

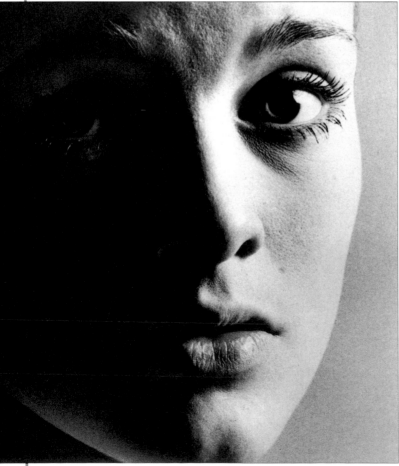

▲ FLOODLIGHTING
For this profile of the British sculptor Henry Moore the primary light source was a single floodlight, slightly above and face-on to him. From the camera's viewpoint, therefore, the lighting is from the side. This is a simple scheme you could emulate with a flash and diffuser.

◄ SPOTLIGHTING
Using the tightly controlled output from a spotlight produces a dramatic, localized effect, very different from the floodlit portrait above. Positioning your subject's face close to a desklight could give a similar effect. For a less controversial result, place a piece of white cardboard on the far side of the light to reflect a little illumination back into the subject's shadow side.

► COMBINED LIGHTING
This portrait of writer Sir Angus Wilson was taken with two diffused studio flash units placed at about 45° either side of the subject, and a small flash unit low down behind him to ensure that his distinguished silver hair was shown to advantage.

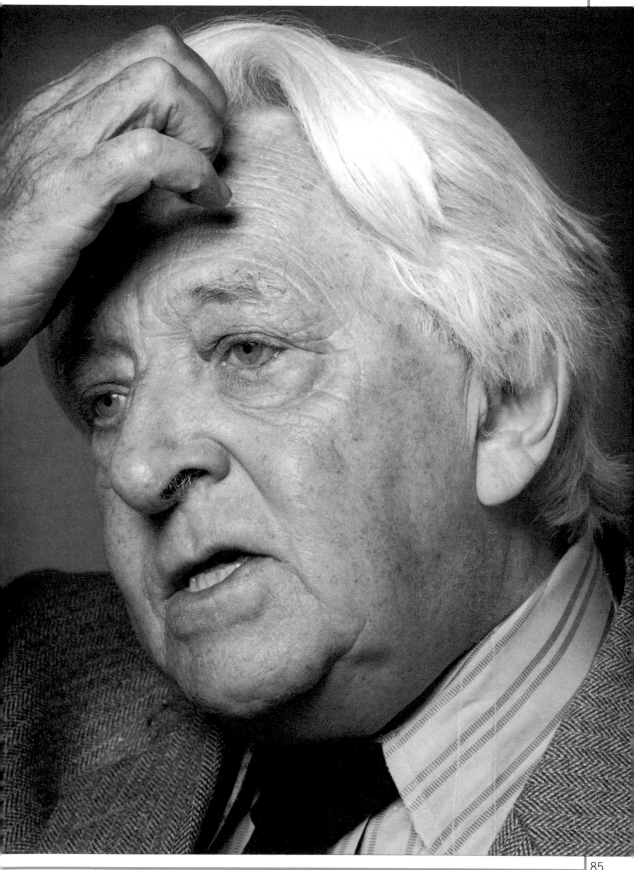

Available light

ALTHOUGH IT IS NEARLY always possible to introduce light from a flashgun, or some other artificial source, into a scene in order to increase the overall illumination, you then run the real risk of killing the very lighting effect that initially attracted you. In the over-whelming majority of cases, it's best to go with the light that is naturally present – the available light – be it daylight, domestic room lighting or even the flickering illumina-tion from a candle. If you look for the right angle from which to shoot, and select the

most appropriate focal length, aperture and shutter speed, you should be able to overcome most lighting problems.

Colour temperature and contrast

One of the benefits of working in black and white is that you don't have to think about the colour temperature of the different light sources present in a scene. You can, for example, mix tungsten and daylight without producing the type of cast that occurs with colour film stock. The high ISO speeds

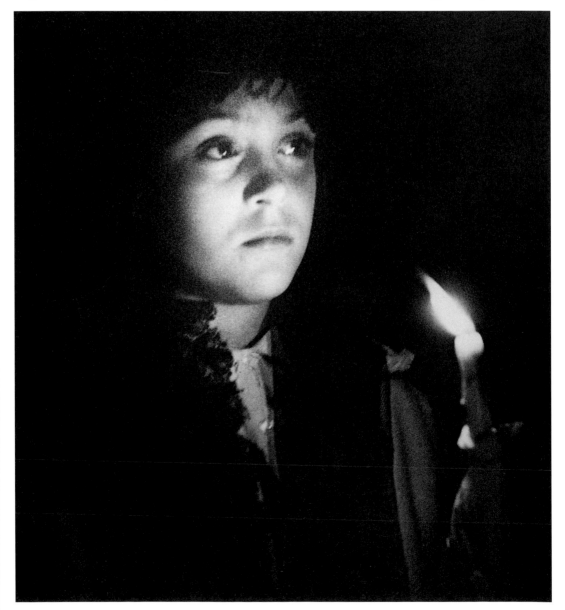

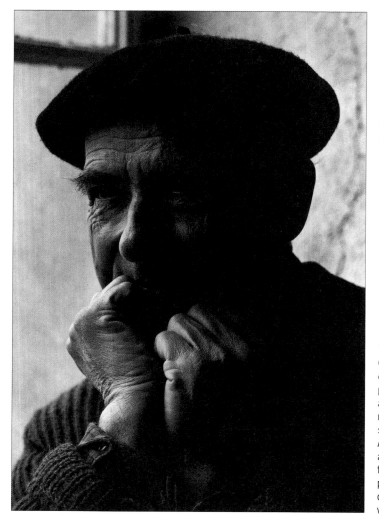

◄ WINDOW LIGHT
In this portrait of a thoughtful Henry Moore, the light from the window is extremely directional. To prevent one side of the sculptor's face disappearing completely into shadow, I used a white cardboard reflector on his shadow side. This gave a little detail on his cheek and reflected the merest glint of light in his otherwise shadowy eye.

▼ SILHOUETTE LIGHTING
One of the essential subject elements is shape, and here I emphasized this characteristic above all others by taking an exposure reading from the bright skylight streaming in through the window. All that was then necessary was to adjust the model's pose slightly so that her underexposed silhouetted profile showed as a clean, graphic outline against the featureless white background.

available in black and white also mean that you can opt for something around the ISO 1600 mark when the lighting is really poor without paying too high a price in terms of image graininess.

However, even with the generous contrast-recording latitude of black and white, you may want to adjust the lighting effect by introducing a reflector to even out exposure differences between highlights and shadows when working with, say, window lighting. And if you intend to make your own prints (*see pp. 134–5*), you will in any event have a large measure of control over the density of specific parts of the image.

◄ CANDLE LIGHT
Even with a high-ISO film, you will appreciate the large maximum aperture offered by standard lenses when taking shots like this. The contrast of the candle lighting is a positive asset when depth of field is shallow.

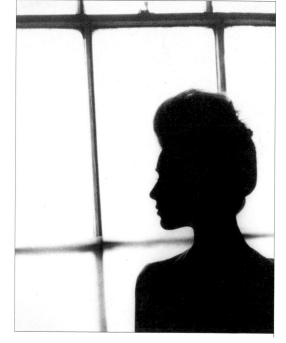

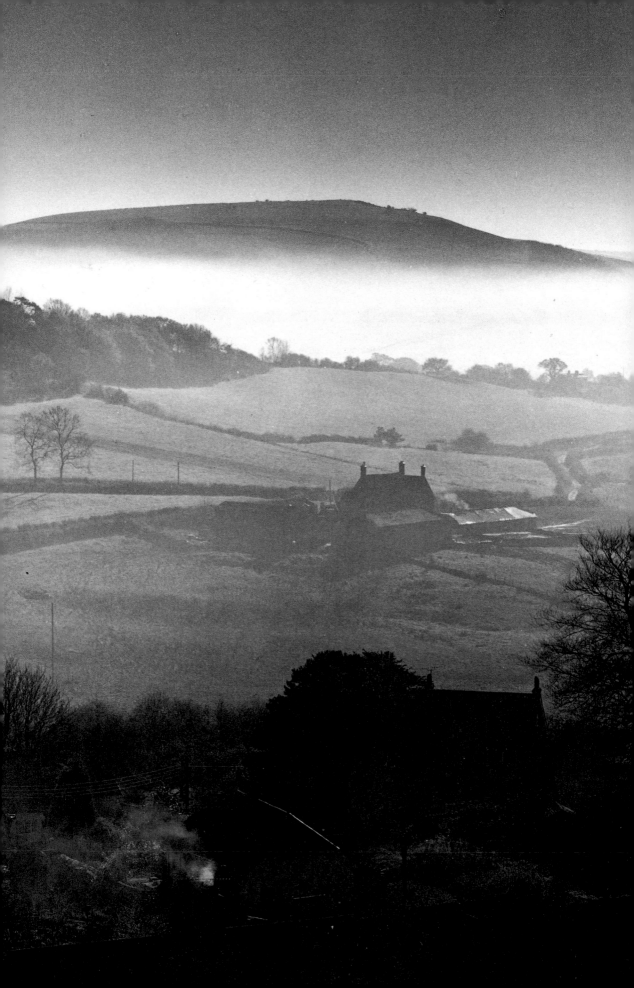

Landscapes

THE TOPIC OF landscape photography is very broad in concept and takes in far more than just rural settings. Most of us live in urban environments, for example – either in cities or large towns – and the only landscapes we are likely to be familiar with on a daily basis are ones largely covered with concrete and tarmac, but no less photographic for that. There are coastal landscapes, too, and here water may be the dominant natural feature. The fascinating aspect of all these landscapes is the way they constantly change, not only when seen at different times of day, but also from season to season, making them an inexhaustible resource for the observant photographer.

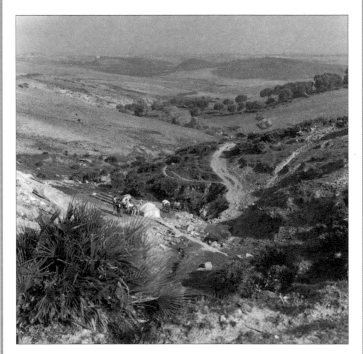

▲ SCALE
Often in a landscape it is important to include something of known size, such as this group of people and their donkeys, in order to impart a sense of scale to the scene.

◀ TONAL CONTRASTS
It is the contrast in tone between the rich, deep blacks in the foreground and the much lighter-toned mist-shrouded background that lends depth and distance to this landscape view.

Foreground interest

L ANDSCAPE PHOTOGRAPHS THAT hold your
attention for more than just a perfunctory
glance have usually been composed so that
the pictorial elements they contain take your
eye on a journey of discovery around the
frame. Any image that reveals all it has to
offer in the first few seconds will not sustain
your interest for very long.

As the starting point for this journey, the
foreground has an important role to play.
First, you can use it as the hook with which
to lead the viewer in. Both of the images on
the right illustrate this point, with the rocks
in the one and the sheep in the other acting
as stepping stones, drawing you deeper and
deeper into the composition. Second, the
foreground can be used as a frame through
which the rest of the image is viewed. The
photograph below is an example of this.

These types of effects are not difficult to
previsualize if you use the camera's view-
finder as your principal compositional tool.

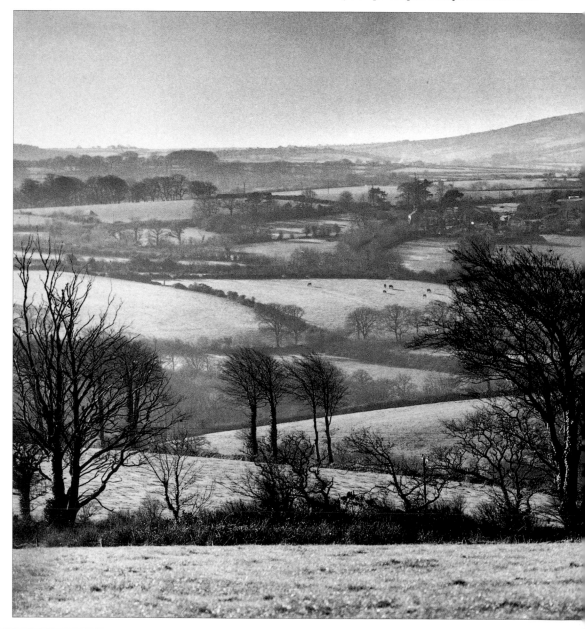

▶ REPEATING SHAPES

Try to imagine how lacking in interest this view of the Mont Saint Michel would be without the repeating shapes of the sheep taking your eye through the frame, where it finally rests on the distant abbey.

▼ FOREGROUND FRAME

Two trees stand in the foreground, and the space between them seems to draw you deeper into the picture. This effect is accentuated by the strong tonal differences between foreground and background.

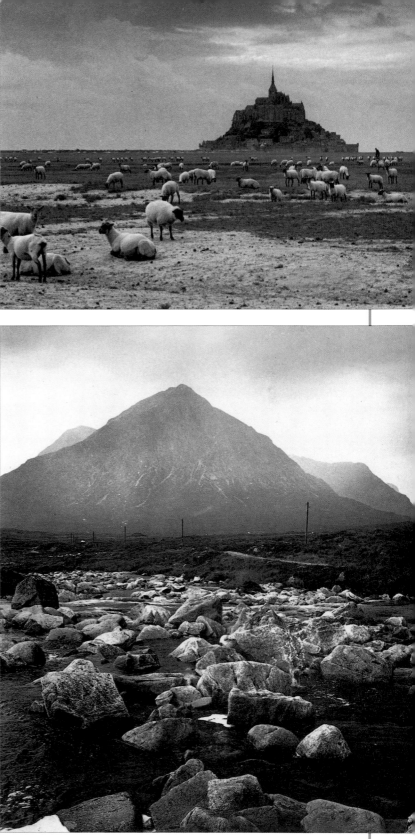

▲ STEPPING STONES

In order to bring the boulders to the very edge of the bottom of the frame it was necessary to crouch down low over the water. All the image planes are well separated here, with the telegraph poles defining the middle ground.

Stressing the vertical

IT IS SURPRISING how infrequently many photographers take advantage of the fact that 35mm cameras have both vertical and horizontal framing options. The camera is more comfortable to use horizontally and so that is how most pictures are taken, despite the requirements of the subject.

Vertically framed images tend to have a greater sense of movement and vitality than horizontally framed ones, and often they contain a better relationship between foreground and background picture elements. In a landscape scene, however, a vertical image may include a large area of sky, so make sure that this works to the picture's advantage before deciding on the framing.

In order to stress the vertical shape of your subject, experiment with different camera positions. A slightly low camera angle looking up at the subject, for example, will emphasize the vertical and any slight tapering or convergence of parallel lines that results may also work to your advantage.

One of the benefits of having your own black and white darkroom is that, even after you have taken the photograph, you can always crop it later at the printing stage (*see pp. 138–9*) to change a horizontally framed picture into a vertical one. And, if the subject matter warrants it, you can crop a vertically framed shot even closer to produce a very long and thin print. If you are working with a square-format camera, compose your image carefully so that it can be cropped at the printing stage if you don't intend to print the full negative area.

◀ **CROPPING**
To emphasize the vertical nature of this composition, part of the negative was cropped during printing. The result is a powerful image, with the direction of the simple wooden grave marker echoing the upward thrust of the cathedral-like tree trunks behind.

▶ **CAMERA POSITION**
Here, a slightly low camera position stresses the vertical thrust of the subject. Note how strongly, despite the disparity in their sizes, the visual link is made between the tree and wooden out-house.

Stressing the horizontal

IF YOU COMPARE the horizontally framed pictures shown below and opposite with the vertically framed ones on the previous two pages (*see pp. 92–3*), you will see an immediate difference in the type and 'feel' of imagery they produce.

Horizontally framed pictures often tend to give more of a sense of affinity between subject elements adjacent to each other, and there is also often a distinct sense of movement across the frame. Strongly horizontal framing is nearly always the first choice for panoramic-type photographs, since this type of framing helps to capture the feeling of spaciousness and atmosphere associated with landscape scenes.

Even if you didn't notice the potential of a scene when taking the picture, it is not too late afterwards to change it. During printing (*see pp. 138–9*) it is always possible to crop the top and/or the bottom and thus leave a horizontally framed image. You can then enlarge the remaining part of the negative to take up most of the printing paper.

▲ **PARTLY OBSCURED SUBJECT**
The low-lying bank of mist partly obscuring the base of the distant hills has helped to stress the horizontal nature of this landscape composition. Seen like this, the tops of the hills seem to be disconnected from the ground and they look as if they are floating as a horizontal band across the picture area.

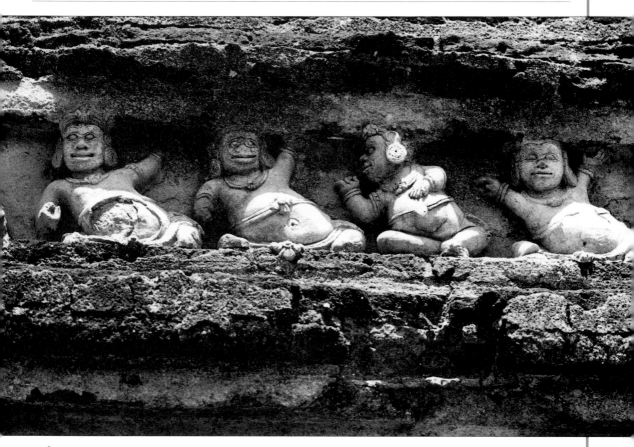

▲ SECTIONAL DETAIL

Many scenes are capable of yielding a strongly horizontal image if you look for suitable details and then isolate them from their setting. This line of carved stonework figures is part of a tall, vertical structure but when framed with the camera held the other way around, the connections between the figures were not as strong or obvious.

▼ DARKROOM CROPPING

In order to emphasize the regularity and repeating pattern evident in this row of attractive wrought-iron balconies in the old part of Sydney, Australia, much of the top of the image and some of the bottom parts were cropped off to produce a long, thin image.

95

Subdued light

THE VERY HIGH SPEEDS of black and white film currently available make it an ideal medium when light levels are subdued. Whenever possible, however, plan to match film speed to the prevailing conditions. If light levels are very low and you feel that your resulting negatives are lacking in contrast, then you could always experiment with different paper grades when printing (*see pp. 136–7*). For a normal-contrast negative, a grade 2 paper is often used; here, however, try printing on grade 4 or 5.

Early morning, before the sun has had a chance to warm the ground, is when you are most likely to encounter mists and fogs. Although this type of lighting makes for wonderfully atmospheric images, you need to watch your exposure quite carefully, since exposure meters tend to read the scene as being brighter than it really is, leading to rather muddy prints lacking any clean, crisp white tones. If in doubt, expose for the shadow areas.

If, when making your prints, you are not happy with the tonal balance, you can always hold back any parts of the image that are printing too dark or burn in areas that are printing too light (*see p. 140*).

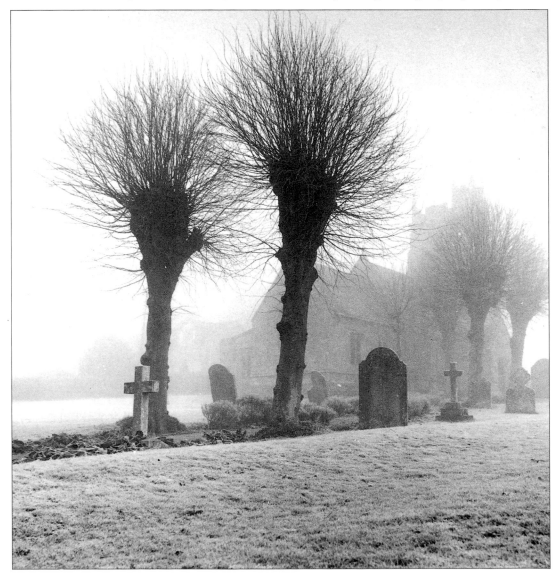

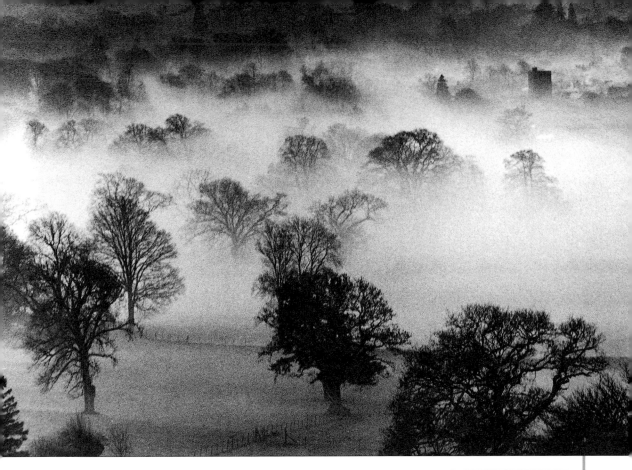

▲ HARD PAPER GRADE

One of the controls available to the black and white worker is the choice of paper grade. For this early-morning shot, a hard grade of paper was selected. The harder the paper the less intermediate tones it reproduces (*see pp. 136–7*), and here you can see that the image is predominantly black and white, with few shades of grey.

◄ SOFT PAPER GRADE

One of the effects of fog is to scatter the available light, producing a softly subdued type of lighting effect. No amount of burning in would produce a satisfactory black, so it is best to use a soft paper grade (*see pp. 136–7*) and go for a more high-key type of result.

▶ MEDIUM PAPER GRADE

Overhead foliage can greatly subdue even bright sunlight, as in this image. Here the negative showed a fully extended range of tones, which made it perfect for printing on a medium-grade paper (*see pp. 136–7*). The result is an image with good, dense blacks, clean whites and a wide range of greys in between.

Contrasty lighting

CONTRAST IS THE DIFFERENCE, assessed subjectively, between the brightest highlights and the deepest shadows contained in a scene. When this difference is extreme – such as at noon when a high, overhead sun creates intense highlights and casts correspondingly deep shadow, or at night when localized light sources from shop signs or car headlights brightly illuminate small areas while leaving most of the scene untouched – then the lighting is said to be contrasty.

While much advice is given to photographers on ways to avoid excessive contrast, many pictures, especially those in black and white, in fact benefit from the extra punch contrast can give. A high-contrast scene has to be approached carefully in terms of exposure, however. It is almost always best to set your exposure either for the highlights and let the shadows block up, or for the shadows and let the highlights burn out. A compromise exposure set somewhere between the two often results in a murky image of mid-tones, lacking sparkle.

▼ **CONTRASTY DAYLIGHT**
The rich blacks and strong whites of this scene are typical of the type of contrast produced by a bright, overhead sun. You can exaggerate this effect further by printing on a hard grade of paper (*see pp. 136–7*).

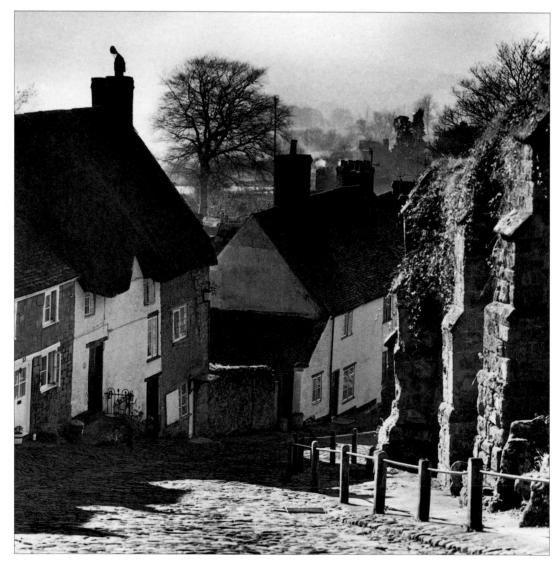

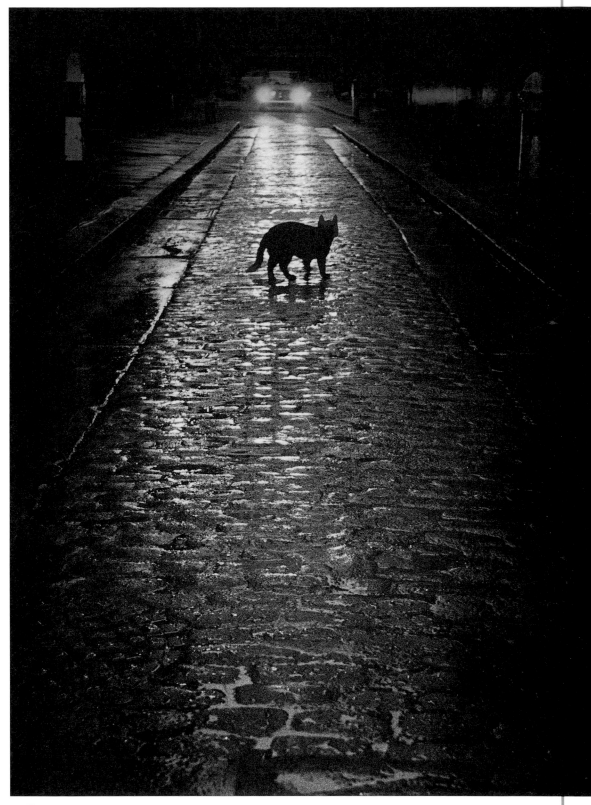

▲ **CONTRAST AT NIGHT**

The beams of light from the car's headlights, although powerful, cannot penetrate far into the oily darkness of night. Everything to the side of the light is therefore unaffected and remains near black. The cat, caught in mid stride, is backlit and side-on to the camera, and so appears as a perfect silhouette.

Adding drama

T HE BLACK AND WHITE MEDIUM is purpose-made for adding a sense of drama to photographs. In normal vision, the landscape is full of colour: scores of different greens, the blues of the sky, coloured splashes of flowers and birds. Take all that away, and at once the world is simplified, becoming a gradation of tones from black to white, and thus giving the imagination the chance to invent its own colouring.

Film speed can be crucial, with the faster-ISO films producing a more obvious grain response that can add to the sense of fore-boding of a dark, twilight landscape scene.

▼ **THE BIRDS**
This camera position, back inside a cave, makes it seem as if the photographer were in hiding, peering out tentatively at a garrulous gang of marauding gulls wheeling by overhead.

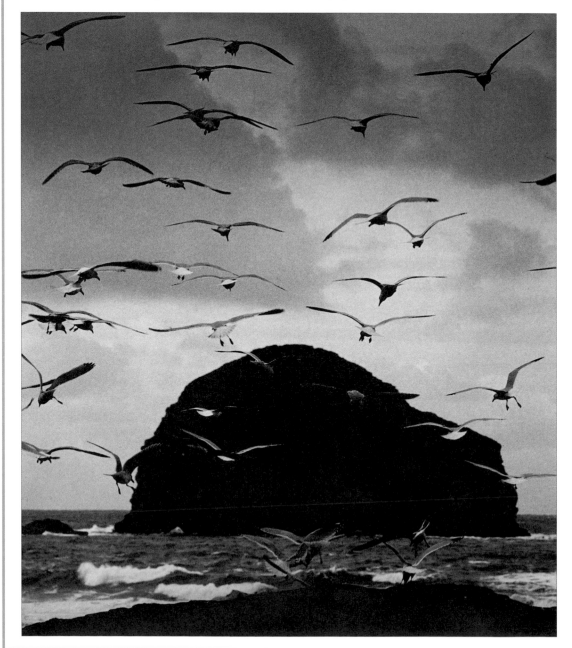

▶ SILHOUETTED VIEW

A camera position halfway down the hillside was the best place to show this single stone cross against the only patch of brightness in an otherwise dark and stormy sky. In order to emphasize contrast, I took the exposure reading from the highlight and allowed the stark monument to show up as a silhouette. The grain of the fast, ISO 400 film used was accentuated a little by slightly extending the development time (*see pp. 130–1*).

▼ STORM LIGHT

A momentary break in the clouds allowed a broad beam of light through to illuminate the dark and bulky form of a castle perched high on a hillside. To increase the sense of drama, a bright highlight was added behind the castle's roof line, using a darkroom technique known as 'dodging' (*see p. 140*).

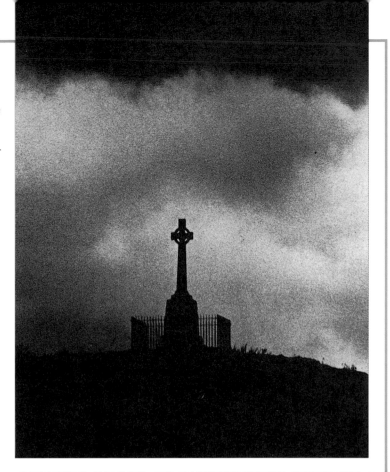

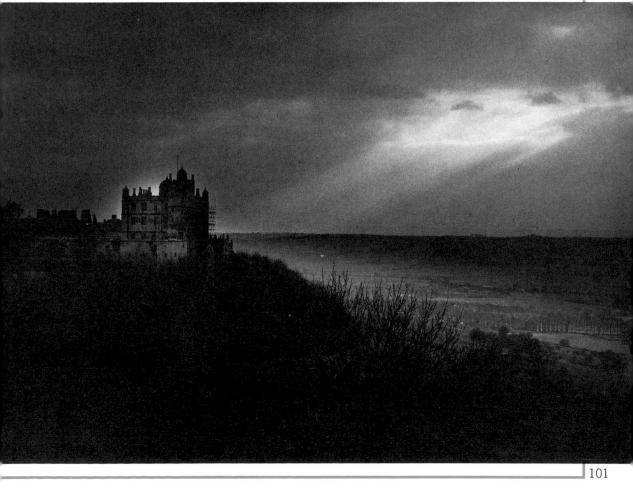

The idealized landscape

WE ALL HAVE in our mind's eye some personal notion of the idealized landscape, a place where man and nature come together in perfect harmony. The hard part, once you have found it, is to transform the colour scene before you into tones from black through grey to white while still capturing, or even enhancing, the spirit of the location.

Composition

Landscape shots most often need to be composed around some prominent feature. Pointing the camera in a random fashion is likely to result in disappointing pictures. Having determined the main focus of interest, experiment with different framings, adjusting focal length if you are using a zoom or changing camera position with a fixed focal length lens. Look carefully at how each change alters the visual relationship between your main subject and the other elements making up the shot.

As with all pictures taken with natural light, the time of day is critical. Generally, the best light for landscapes occurs in early morning and late afternoon. Light levels at these times may be lower than at noon, but the quality of the more directional illumination is superior. The overhead light of noon tends to destroy the illusion of form and depth, whereas the more oblique light of morning and afternoon strengthens them.

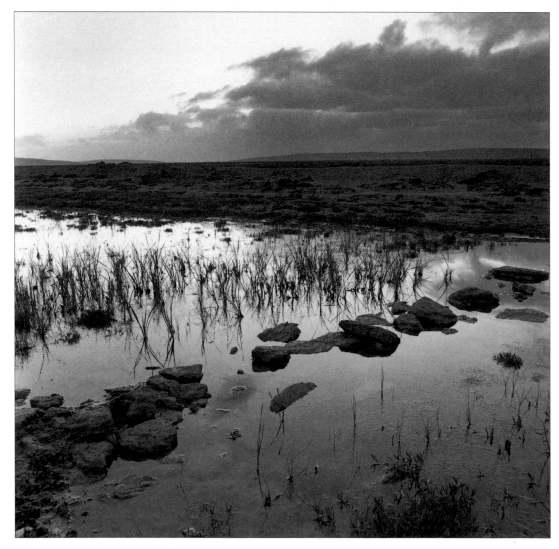

◀ DUSK LIGHT

In this type of flat meadow landscape, finding a promi-
nent feature around which to compose your picture
can be difficult. To achieve it in this example, it was
necessary to find just the right camera position and
angle so that the foreground water reflected the
rapidly dimming dusk light, creating a welcome
highlight in an otherwise flat-toned scene. Of equal
importance was showing the stepping stones leading
across the waterlogged ground. These, in fact, are
visually extremely important to the composition, acting
as lead-in lines (see pp. 26–7) that take the viewer's
eye across the water and into the landscape proper.

▲ RUSTIC HARMONY

This is an ideal type of rural scene – a broad river
meandering through a tree-filled landscape. The only
intrusion of man is a rustic wooden fence, sensitively
integrated, and with a stile to allow ramblers to cross
unhindered. Here, too, the right camera position was
crucial, for it is the fence and gate that bind this com-
position together and prevent the bright highlight on the
water beyond becoming too prominent a feature in the
scene. Angling the camera just slightly more in line with
the river would also have brought more of the field on
the left into view, and this was the least attractive
aspect of the setting.

Romantic landscapes

THE IDEA OF THE ROMANTIC LANDSCAPE means different things to different people. Each of us draws on our own background and experiences to bring together in our mind's eye the various elements that go to make up that special, romantic setting.

Media input

Our notion of the romantic landscape must also be heavily influenced by the thousands of different images that are presented to us throughout our lives – the works of landscape painters seen in books, postcards and galleries, holiday posters on trains and billboards, and advertisements on television.

Your best approach is to look for a specific focal point around which to build your composition. This is always better than just snapping away. Analyse what it is about that scene that appeals to you, think what the key components of the scene are and then make sure that these features are also prominent in the way you frame the shot. It may be the way the light falls through the trees, creating areas of highlight and shadow, or it could be the pattern and texture of a carpet of fallen leaves. Until you bring to the forefront of your mind what it is that attracts you to the scene, you will have trouble recording it on film.

◀ **THE COUNTRY COTTAGE**
Glimpsed through overgrown shrubs and tall heads of flowers and grasses, a beam of sunlight lighting the way, the perfect country cottage – with vine-clad walls – nestles peacefully beneath the towering trees.

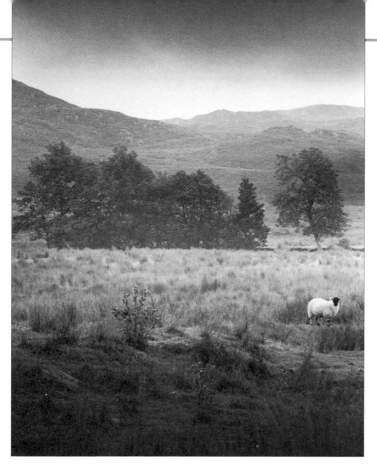

◄ COUNTRY IDYLL

With sunlight playing across the gentle hills, and a copse of trees helping to define the middleground, you can almost hear the soft murmur of insects and the distant call of bird song. And to round off the scene, a sheep stands and stares contentedly back toward the camera, providing both foreground interest and a sense of scale.

▼ WATER

Water is one of the very most emotive of all the romantic devices. Here, the still surface of a placid river returns perfect reflections of the bankside trees and, invitingly in the foreground, a boat seems to beckon us into the frame.

Skyscapes

THE EVER-SHIFTING PATTERNS of clouds across the sky provide the landscape photographer with an unending source of inspiration. However, because black and white film reproduces blue as a light tone, often it is necessary to use a coloured filter to help restore or dramatize the tonal difference between the white clouds and blue sky (*see pp. 36–7*) – depending on the effect required, try a yellow, an orange or a red filter. Slight underexposure will also help contrast.

By pointing the camera directly upward you can exclude the land completely from the composition. Often, however, better pictures result from having at least a ribbon of land at the bottom of the frame. An exposure taken from the sky, usually the brightest part of the scene, will probably leave the landscape underexposed, but it still important. First, it helps to define the picture area and, second, it provides a scale against which the the size of the sky can be judged.

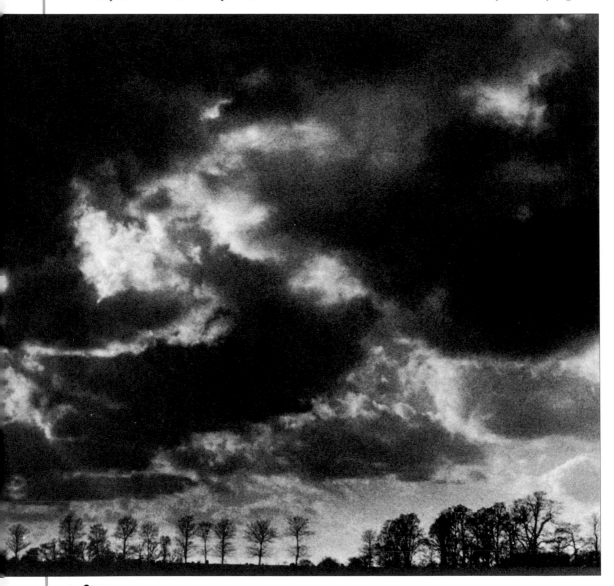

▲ SCALE

Only a ribbon of land remains, but the trees silhouetted against the bright sky toward the horizon, although fully grown and large, seem tiny compared with the enormity of the background of sky and cloud.

▶ INCREASING CONTRAST

The dramatic lighting in this cloud-dominated sky was enhanced by fitting an orange filter to the camera lens (*see pp. 36–7*). The sky now appears much darker in relation to the white clouds and the scene has really come to life.

▼ USING TONE TO EFFECT

The ruggedness of this coastal scene has been mitigated by a soft-toned interpretation. By printing on a soft-grade paper (*see pp. 136–7*) strong blacks and stark whites have been largely avoided.

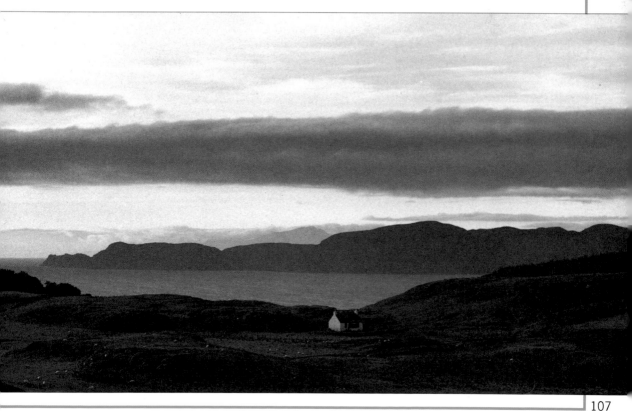

Water views

INCLUDING WATER IN a photograph can give a new dimension to your picture. If the surface of the water is calm, and the angle of the light right, a body of water can turn into a perfect mirror-like reflector, repeating not only the shapes of the clouds above but also any features on the surrounding shoreline.

When the surface of the water is ruffled, other picture possibilities begin to emerge – abstract patterns of light and shade, for example, or star-like sparkles of intense highlight and zigzag reflections of familiar objects that can make fascinating subjects for the camera in their own right.

Fast-flowing water is different yet again. Here you can use a fast shutter speed to freeze its movement or a slow speed to create a soft, impressionistic blur.

▼ **GENTLE RIPPLES**
Backlit and silhouetted, a small fishing boat and tender push through the calm water creating just sufficient disturbance to the surface to produce a slightly jagged, distorted set of reflections.

▲ REPEATING IMAGES

Low, evening light partially illumi-
nates an old, stone-built boathouse,
whose reflection is seen as a re-
peating image in the placid waters
of the lake. The sense of depth is
produced by the significantly lighter
tones of the distant hills. This is
known as aerial perspective.

▶ CHOOSING A SHUTTER SPEED

A shutter speed of 1/15 sec was
used to photograph this rapidly
flowing stream. For maximum
impact, the soft blurring and
streaking of the water has to be
contrasted with the pin-sharp clarity
of the surrounding rocks. To
achieve this, use the smallest
aperture your lens has to offer and
mount the camera on a sturdy
tripod. If the light is bright, how-
ever, and you have a fast film in the
camera, you may have to use a
neutral density (ND) filter to avoid
overexposure.

◀ CHOOSING AN EXPOSURE

With a backlit scene you have to
decide whether to set exposure for
the shadows and let the highlights
burn out, or to expose for the bright
areas of the frame and let the
shadows fill in, as in this example.

Reflections

THE PRESENCE OF A BODY OF WATER often adds another dimension to a photograph. The surface of still water can introduce a certain 'confusion' to a picture, becoming a mirror-like surface reflecting an image so perfect of the surrounding shoreline features or sky that it is difficult to tell which is real. Moving water, or that disturbed by a pebble or stone, is entirely different, with the reflected image distorted in all manner of unpredictable ways. Sometimes the image will still be recognizable as a reflection of the original; sometimes it will be a wildly chaotic and an abstract pattern of tones.

You do not need a large amount of water to add reflections to a photograph. Next time it rains, notice how even quite small puddles of water in the roadway or gutter can reflect back images of the surrounding buildings, trees or sky. However, you will have to search to find the best angle so that the reflections add strength and excitement to the picture, and show just that part of the scene you wish to record.

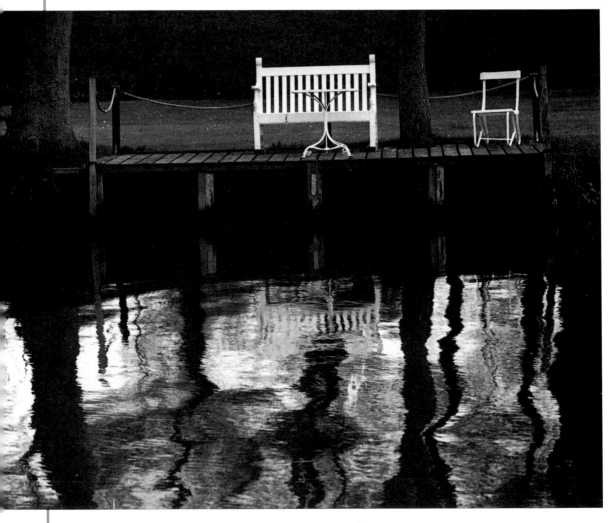

▲ DISTURBED WATER
Composing the image with the water at the bottom of the frame has added real interest to the foreground. The arrangement of garden furniture at the top has a graphic simplicity, while the distorted reflections give a very different interpretation of the same scene.

▶ CALM WATER
The strong lines of the bridge and lamp in this shot help to define and contain the rest of the image, which is shrouded in morning mist. In the calm water below, however, the mirror-like reflection shows a stronger, more contrasty and detailed view of the scene.

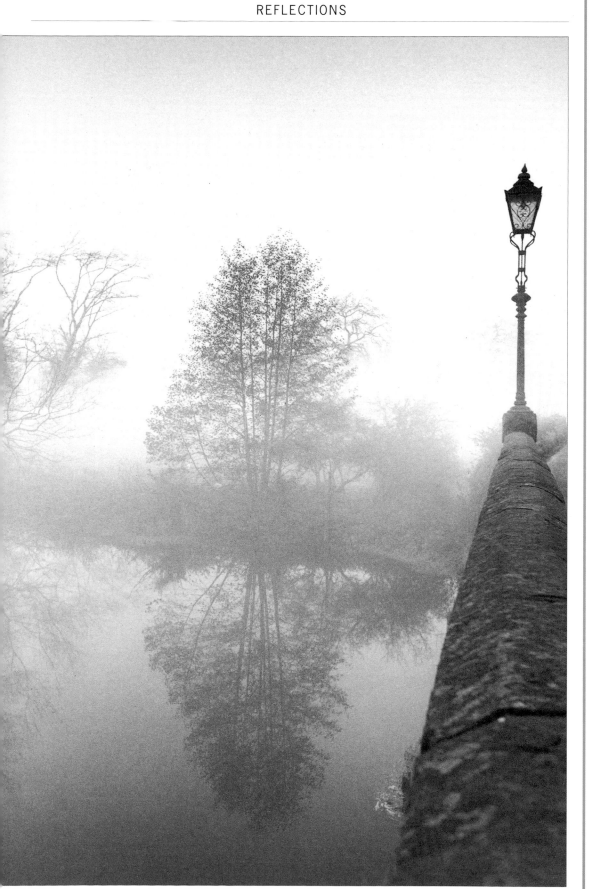

People in a landscape

THE THREE PHOTOGRAPHS on these pages depict very different types of landscape – a beach scene; a vast, largely featureless plain in the heartland of Romania; and a misty English orchard in winter – but each has been brought to life by the inclusion of the human figure.

There is virtually no landscape left on the planet where the hand of man is not somehow in evidence, so the inclusion of people in the frame can lend a certain authenticity to your pictures. More important, however, the human figure is of known size, and so the scale of the landscape in which it is portrayed can easily be gauged by comparing one with the other. The figure does not need to be the principal subject of the shot to fulfil this function, nor does it even have to be particularly prominent. Using a tripod, or some other type of support, and your camera's self-timer you could even include yourself in the picture.

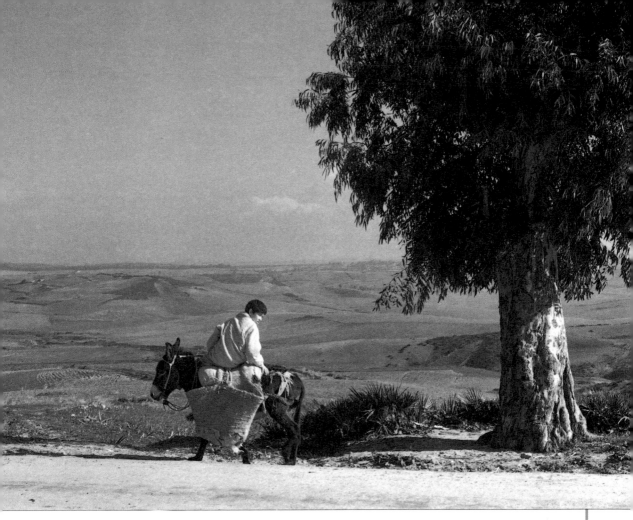

▲ THE IMPORTANCE OF SCALE
Without the inclusion of this boy and his donkey in the shot, it would be impossible to gauge either the size of the foreground tree or the extent of the landscape it overlooks.

▶ HUMOROUS CONTENT
The gloominess generated by the damp, clinging fog lying low over the ground of this wintry orchard scene is relieved by the humorous inclusion of the back view of a man carrying a piece of garden statuary.

◀ EXPOSING FOR EFFECT
The inclusion of bathers is vital for the success of this beach scene. About a 2$1/2$-stop 'overexposure' was necessary to burn out the detail of the water and sand and leave the figures slightly reduced in prominence as the intensity of the light eats into their form.

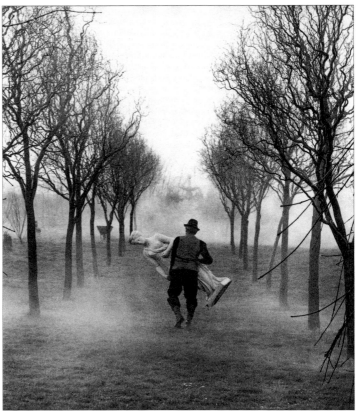

Buildings in a landscape

ARCHITECTS OFTEN STRIVE to integrate their buildings into the surrounding landscape in an attempt to create a pleasing union between nature and the needs of people. Buildings that are a part of older communities, ones that grew gradually over long periods of time, are often the most attractive because it is these that seem to fit most naturally into their local landscapes.

Before the modern-day pressures of urban sprawl, structures would be erected wherever possible to take best advantage of local circumstances. Buildings would be tucked into the lee of the surrounding hills, for example, which would offer some protection from wind or drifting snow. Houses and other buildings would also most likely be made from locally available materials, such as stone and wood, and so they would not

appear as starkly intrusive as many more recent examples of urban town planning.

Lenses and viewpoints

Buildings in their own garden or grounds are often designed to be seen at their best from one particular viewpoint. A break in a hedged boundary, for example, may afford you the best camera angle, or an avenue of trees may lead the eye naturally toward the building featured at the far end.

The type of lens to use depends on the size of the building and area of landscape to be recorded, as well as on shooting distance. A wide-angle close in tends to make a small setting seem larger and more spacious; a longer lens used from farther back can make the building and any nearby hills, trees, and so on look more intimately connected.

◄ FRAMING A BUILDING
By choosing a camera position midway between two trees, the distant church seen through the clearing appears in a natural frame and immediately becomes the focus of attention. The effect is to depict what is obviously a rural church in a very sympathetic and entirely appropriate fashion.

◄ USING REFLECTIONS
A modern building in a flat, desert setting represents a photographic challenge. The answer here was to use the small area of foreground standing water to reflect part of the structure beyond.

► ADDING FOREGOUND INTEREST
The viewpoint chosen for this shot shows a large country house partly obscured by nearby trees. The most dominant feature here, however, is the foreground tree, which is leaning at a dangerous angle after being uprooted by high winds.

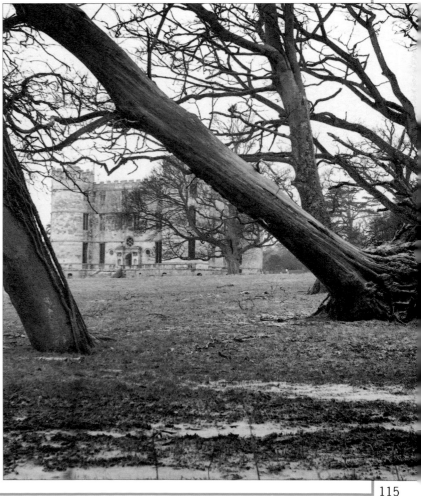

Urban landscapes

THE URBAN LANDSCAPE is perhaps not generally thought of visually exciting, but it is undeniably so. While you can't liken the towering buildings of a city centre to a forest of trees, or compare the ribbons of tarmac roadways with the meandering channels of rivers, the photographic approach can be surprisingly similar.

Unless your intention is to accentuate such features as pattern, repeating shape or texture, the need for a strong composition often means finding a principal focus of attention. Lighting direction is also vital, with morning and afternoon sunlight often providing the most striking contrasts. And scale is just as important in an urban as in a rural setting, to add a sense of drama and a way of gauging the extent of the scene.

And at night, when the streets are full of lights from houses, cars, stores and signs, you can load the camera with fast film and carry on shooting.

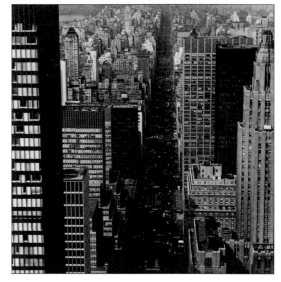

▲ **REPEATING SHAPES**
An overhead view looking deep into the canyon below was the best way to stress the city's angularity, and to emphasize the repetition of rectangles and squares making up both the outline and detail of the buildings.

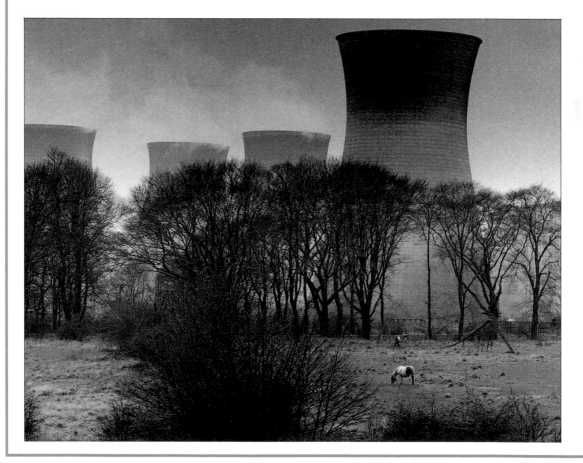

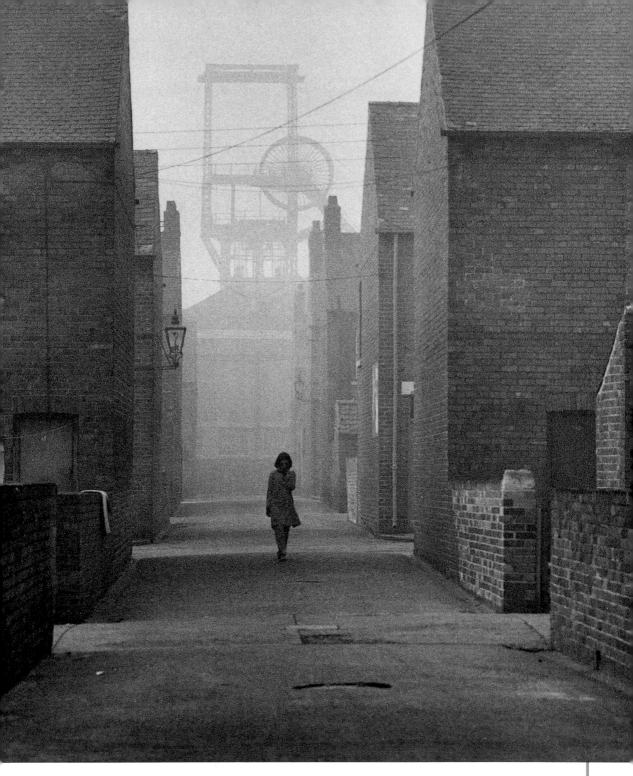

◄ POWER PLAY
Looking incongruous in a predominantly rural setting, these four massive power station cooling towers loom ominously above the foreground field. The bare winter branches of the tree in the immediate foreground help to mask off much of the field to the left of the picture, so concentrating the viewer's attention on the pony grazing unconcerned and the children playing on the swings as the pollution drifts overhead.

▲ TELEPHOTO COMPRESSION
This industrial urban scene was shot with a 250mm lens. Its very narrow angle of view has excluded much distracting detail between my camera position and the female subject, and I was far enough away for her not to take any notice. One of the effects of a long lens like this is to compress the apparent distance between objects. This has made the houses appear to be built closer together and has also enlarged the background in relation to the foreground, making the pit engine seem oppressively large and close.

Architecture

THE SUBJECT OF architectural photography is broad. As you can see from the pictures on these pages and those that follow, buildings include grand country houses and cathedrals as well as humble corner shops, ruined shells, architectural details and the less-familiar building styles of far-off places.

Time of day

The direction of light striking the subject is critical, and this is dependent on the time of day and the sun's position in the sky. Frontal and toplighting has the effect of flattening contrast, assigning similar tonal values to all parts of the building, and thus decreasing the sense of depth. Sidelighting, however, will strike some parts of a building while throwing others into shadow. The contrast between lit and unlit surfaces exaggerates the texture of the building's façade and often creates a more interesting interpretation.

Rather than take a picture from the angle you first come across, take the time to walk around the subject. If the light is not perfect on one face of the building, it may well be just what you are looking for at the side or rear. This way, you may also avoid including people in the shot.

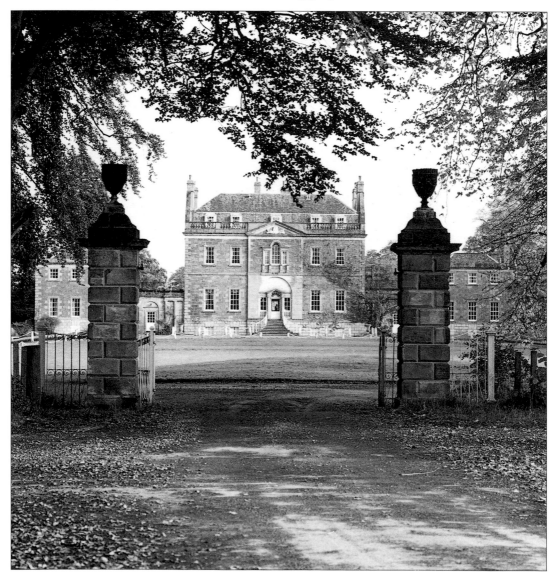

▶ WIDE-ANGLE DISTORTION

Typical of religious architecture in parts of Thailand and Cambodia, this shrine, or *chedi,* has been photographed with a wide-angle lens used close to the base of the structure. With the lens pointing upward, note how the building's already tapering top has been exaggerated, producing a much steepened perspective.

◀ FRAMING

To mask a large area of toneless sky, the camera angle was carefully selected to show the building framed by overhanging foliage.

▲ TIME OF DAY

A low sun throws shadows across the lawn, striking only the prominent features of the building. The shadows created give a strongly three-dimensional result.

▲ LENSES TO ISOLATE

A moderate telephoto lens was used to take this shot of what has become almost an historical footnote – the local corner shop.

Choice of lens and camera position

The most generally useful lens for architectural photography that non-specialists are likely to own is probably a zoom, one with a focal length range of about 28-70mm (for 35mm cameras). The wide-angle end of this range will allow you to include all of even quite large buildings from reasonably close-up, although some edge distortion may be evident in the resulting pictures. The tele-photo end of the range is also useful, since it will not dramatically compress subject planes yet it is still long enough to isolate small subject details than cannot easily be approached or are positioned high up.

Moving in with a wide-angle and pointing the camera up to include the tops of buildings produces an effect called converging verticals, which, although dramatic, make structures appear to topple backwards. A special shift lens will prevent this happening because the lens can be shifted off centre while the camera, and film, stay parallel with the subject.

▲ **ARCHITECTURAL DETAIL**
Sometimes you want to record only a small detail of a building, such as in the example here. To restrict my angle of view and get the subject large in the frame, I needed to use a telephoto lens. For a larger, closer detail, a standard lens would have been appropriate.

◄ **REPEATING PATTERN**
The best angles for photography can often be the most unlikely ones. In this overhead view, the buildings' most attractive features – their symmetrically tiled roofs – are emphasized as a repeating pattern of light and shade created by the raking light of a low sun.

► **UNLIKELY CANDIDATE**
The interior of this building was gutted centuries ago, and what the low camera position has now recorded are the bare bones of the architecture – soaring pillars and massively heavy stone walls pierced by elegant window arches.

Interiors

Uₙₗₑₛₛ you can bring a lot of artificial light to bear, you will usually be heavily dependent on daylight entering through windows or doors when photographing interiors.

In a large interior, window light may result in large areas of impenetrable shadow in the farther reaches of the space so, rather than include the whole interior, concentrate on well-lit details instead.

In a small-scale interior, problems are usually fewer and easier to solve. Even if window light does result in dark areas, these can often be relieved with a small flashgun or a reflector or two. And using black and white film means that you can turn on the ordinary domestic room lights to boost the overall level of illumination without having to worry about colour casts.

▲ **SMALL-SCALE INTERIOR**
The light from a small flashgun was masked off with a piece of cardboard to keep the left-hand side of this traditional country kitchen in darkness. This simple ploy has increased the feeling of intimacy and coziness of the scene.

▶ **INTERIOR DETAIL**
This small section of the stairwell of a modern building presented the best opportunity for a uniformly lit image. The selective view from overhead has also created an interestingly abstract set of flowing, geometric lines and shapes.

◀ **LARGE-SCALE INTERIOR**
Luckily, the interior of this church building was well endowed with windows. This made the lighting generally even, but still a tripod was essential to hold the camera steady during a 1 1/2 sec exposure at f16. The striated lighting effect is caused by beams of sunlight scattering in the dusty atmosphere.

Darkroom techniques

IN YEARS GONE BY, photographers began by taking black and white pictures and only when they were proficient in that medium did they move on to colour. In those days, a darkroom was a major part of the photographer's equipment, whether amateur or professional.

Today, it is different. Photographers begin with colour and, right at the start, nearly all tend to use highly automated photographic laboratories to develop and print their work.

Black and white photography, far from being the necessary place to start, has now become the creative medium that some photographers move on to from colour. When that happens, they might try to get their work developed and printed commercially. The results are, more often than not, disappointing. Commercial laboratories are not set up for black and white processing the way they are for colour and, unless you pay top prices for top, professional printers, you will never get the type of quality you hoped for. Nor will you have the creative control over your film developing and print making that is so much a part of good black and white photography.

The answer is to set up your own darkroom at home. For the black and white worker, this is neither as difficult nor as expensive as you might imagine. And you will be surprised at how quickly you start to learn the basics of the print-maker's craft.

◀ **DARKROOM CONTROL**
A multiple print such as this (*see p. 141*) creates an intriguing composition. Only with your own darkroom, however, can you have full control over the look of the final print.

Setting up a darkroom

THE PRIME NEED for a darkroom is a contained area that can be blacked out. This is not that difficult, especially if you have an internal room or a closet without windows. If there is a window, cover it with a light-proof shutter or buy blackout blinds from a specialist camera store. Don't forget to check the door area. A lot of light can find its way under and around a door and its hinges. Commercially available draught excluder can be used to help here.

Another important requisite is electricity. This is not likely to be a problem if you are using a normal room in the house, but if you are converting a bathroom or understairs cupboard, use a professional electrician to take care of any installation.

You will need facilities for two lights – a normal white (room) light and a special darkroom safelight. Each will need its own draw cord switch to guard against touching electrical switches with wet hands. You will also need an electrical socket for the enlarger and at least one other for a timer or dish warmers.

Running water is a big advantage in any darkroom, but it is by no means a necessity. Providing you have access to running water nearby, much darkroom work can be carried out with just a bucket of fresh water.

In any darkroom, divide the space between the dry side – the enlarger, negatives, printing papers and switches – and the wet side – chemicals, processing dishes and water supply – in order to avoid accidents.

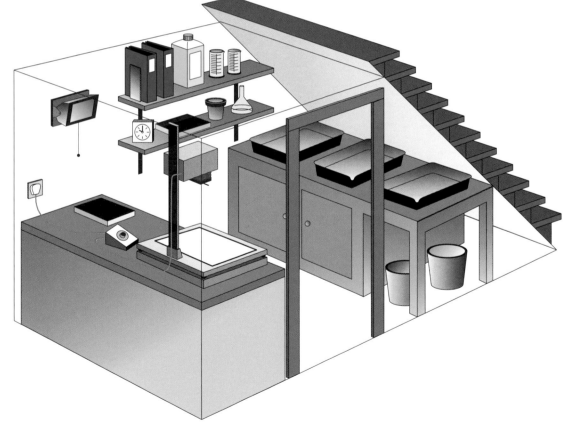

▲ **UNDERSTAIRS DARKROOM**
An understairs cupboard can make a suitable darkroom, with the advantage of there not being a window to worry about. Plan the available space carefully. Because of the sloping stairs above, one end of the room will be higher than the other, so start by positioning the enlarger where the head can travel to the top of its column. Build in benches at a comfortable working height and position processing dishes as far away from the enlarger as possible. Include storage cupboards and space for a water bucket.

To black out a bathroom, fit a light-proof blind that can be rolled up when the darkroom is not in use. You can buy blinds set in a frame with Velcro along the sides to improve the light seal.

Place a board across the bath to make a working surface and wash prints in the bathroom sink.

Bathrooms do not have conventional electrical sockets, so you will need an extension cable with a distribution box.

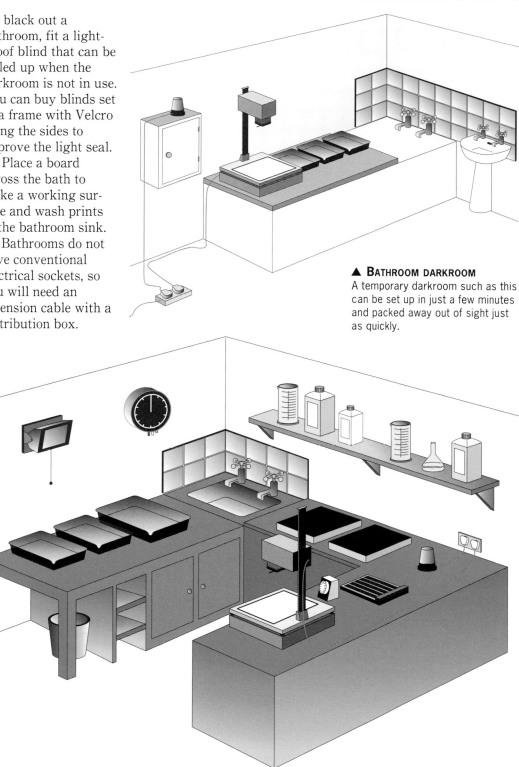

▲ **BATHROOM DARKROOM**
A temporary darkroom such as this can be set up in just a few minutes and packed away out of sight just as quickly.

▲ **PERMANENT DARKROOM**
If you have the space for a permanent darkroom, black out the window and door, have running water laid on and adjust the position of electrical sockets to bench height. Paint the room white to reflect the safelight, but paint the area around the enlarger itself matt black.

Organize two distinct areas: a dry bench for the enlarger and a wet bench for the processing dishes. A light-tight extractor fan is useful to keep the air circulating – important in a room with no window and in which chemical fumes can sometimes prove unhealthy.

Equipping the darkroom

EQUIPPING A HOME DARKROOM is not nearly as complicated, or as expensive, as you might initially think.

Black and white darkroom work is divided into two areas: developing and printing. Development is when you take the film from your camera and process it in standard chemicals to produce a strip of negatives. Printing involves taking those negatives and, using an enlarger, producing a set of prints from them. The processing stages for film and print developing are very similar.

You can get started with only the most basic equipment. It can be bought new from a good photographic dealer, but darkroom equipment, and even complete darkrooms, are often seen for sale secondhand in the classified advertisements found at the back of popular photographic magazines.

▲ TIME, TEMPERATURE AND LIGHTING
A darkroom clock is better than using your watch for timing. It has a large face that is easy to read and counts off minutes and seconds in ascending or descending order. Printing paper is insensitive to the colour produced by a darkroom safelight, so black and white printing can be carried out in its light. The thermometer is used for checking the temperature of chemicals used in processing. In black and white, only the developer temperature is critical.

▲ BASIC EQUIPMENT
The developing tank (*right*) is a light-tight container with a light trap in its lid. Chemicals can be poured in and out, but light is prevented from entering. Inside the tank, the film is held on a plastic spiral.

Two basic chemicals are needed for developing and printing: developer and fixer. A stop bath is also useful, but it can be replaced by plain water. The same fixer can be used, at different dilutions, for developing film and for making prints. Although some 'universal'

developers can also be used for both processes, it is advisable to use different types of developer for processing film and paper.

The dishes are used only for printing. Since the process can be carried out by safelight, there is no need for light-tight equipment at this stage.

The graduated cylinder is used for measuring the dilution of the chemicals, and the tongs are useful for lifting prints in and out of the processing trays.

The enlarger is rather like a projector, only one that projects its image vertically on to a baseboard, rather than horizontally on to a wall or screen. It is used to project and size the negative on the sensitive printing paper.

You can alter the size of the print, or crop it for the best composition, by adjusting the height of the enlarger head above the baseboard. Sharpness is defined by the enlarger's focusing control. The enlarger lens has f stops, just like a camera lens. Stopping the lens down reduces the brightness of the image and, just as small apertures increase depth of field in a camera lens, so this also helps to ensure accurate focus on the baseboard. Always focus at maximum aperture, however, to take advantage of the brightest possible image.

The printing, or enlarging, easel on the baseboard holds the paper flat. By moving its adjustable arms, you can decide on the shape of print you want by masking off the edges of the paper to leave white borders. Standing on the baseboard is a magnifier, used for checking focus of the negative.

Beside the enlarger is a timer, which is used to time the exposure of the paper. Just as with a camera, stopping the lens down requires longer exposures, but instead of the fractions of a second usual for film, paper requires many seconds of exposure time. If linked electrically to the enlarger, the timer automatically turns the light off when the appropriate time has elapsed.

When setting up the enlarger, make sure that it is positioned on a solid, flat surface that is not prone to vibrations. The slightest movement of the enlarger during printing will spoil the print.

▼ CHOOSING AN ENLARGER
The enlarger is the most expensive piece of equipment you will have to buy when equipping a darkroom. It is also the most important, so buy the best you can afford. Make sure that the enlarger is sturdy and does not wobble easily. Check that the movement of the head up and down on its column is smooth. Enlargers are sold with a choice of lenses, so always buy the best quality you can. There is no point taking pictures with an expensive camera lens and then printing them through an inferior enlarger lens.

Processing silver-based film

WITH THE DARKROOM EQUIPPED, you are ready to begin processing a film. For this stage you only need a developing tank and a spiral. You must remove the film from its cassette and load it into the tank in total darkness, but once the lid is in place, all other steps can be carried out in normal room lighting. If you to use a changing bag (a light-tight cloth bag with elasticated openings to insert your hands) you don't need a darkroom at all for this stage.

◄ **TANK TYPES**
The developing tank uses a spiral to hold the coils of film apart. Different sizes can be used depending on whether 35mm or 120 rollfilm is being developed. Some tanks take two spirals so that two films can be processed at the same time.

1 Ensure the spirals are clean and dry before starting. In darkness, remove the film from its cassette, cut off the shaped leader and feed the end into the opening of the spiral.

2 Hold one side of the spiral and rotate the other until you feel it stop. Turn the first side back and repeat the process. By this means, the whole film is fed into the spiral.

3 If the film jams, gently unwind it a little and try again. Never force the process. When the whole film is in the spiral, use scissors to cut it away from the cassette spool.

4 Place the loaded spiral into the tank and spin it to make sure that there are no obstructions. Replace the lid of the tank. The ordinary room light can now be turned on.

Chromogenic film

This film is processed in C-41 colour chemistry, and many photographers have it developed commercially. The chemicals are available in kit form, however, and the resulting negatives are printed just like conventional black and white films.

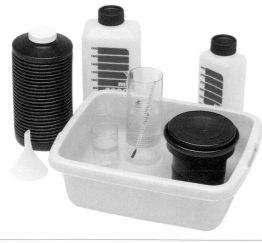

▲ **PROFESSIONAL TEMPERATURE CONTROL**
When processing chromogenic film, the temperature of the chemicals is critical. One way of keeping the temperature constant is to buy a processing unit with a thermostatically controlled water bath surrounding the chemicals. A motor turns the developing tank to ensure even processing.

◄ **INFORMAL TEMPERATURE CONTROL**
If you do not have a professional processing unit like the one above, stand the chemicals and film-processing tank in a bowl of water that has been pre-heated to the correct temperature. Add more warm water from a kettle as the temperature in the bowl drops below that recommended.

With silver-based black and white film, only the temperature of the developer is critical if you want to hold to the recommended timings. While the temperatures of other solutions should not vary by wide amounts, these do not affect the timing or the effectiveness of the chemistry, in the same way as they do with the developer. If the temperature of the developer differs from that recommended you will need to adjust the length of this processing stage. Details of development time, within a range of temperatures, are given in the developer's instruction sheet. Development time also varies with the speed of the film. Always take the time to read and familiarize yourself with these instructions.

5 Dilute the chemicals according to the instruction sheet. Once diluted, check the temperature – 68°F (20°C) is usually recommended.

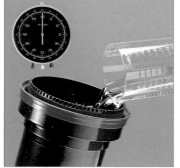

6 As you pour the developer into the tank, start the timer. Pour in a steady flow, then gently rap the tank to dislodge air any bubbles.

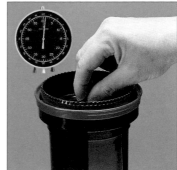

7 Rotate the spirals for 10 seconds in every minute during development, or invert the tank, to bring fresh developer into contact with the film.

8 When development time is up, pour the developer away. The best developers are 'one-shot' solutions – used once and then discarded.

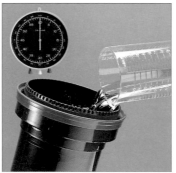

9 Reset the timer to zero and pour in the diluted stop bath. This stage can be replaced by two or three washes in water.

10 If stop bath is used, pour it out of the tank after the time recommended in its instruction sheet. This solution can be kept for re-use.

11 Reset the timer to zero and pour in diluted fixer. Agitate the spiral regularly throughout the time recommended in its instructions.

12 Pour out the fixer and keep it for future films. Wash the film in gently running water, and after about 30 mins hang it up to dry.

13 Use squeegee tongs to remove excess water droplets, and then leave the film in a dust-free area until it has completely dried.

Assessing the negative

ACORRECTLY EXPOSED, correctly developed negative should have a full range of tones from nearly clear to almost solid black. As a general rule of thumb, place a negative on a sheet of newspaper. If it has been correctly exposed and developed, you should just about be able to read the print through the darkest areas.

Underdevelopment produces a low-contrast negative with a thin image in which highlights and shadow areas vary very little in intensity. Overdevelopment, however,

Correct exposure, correct development

▲ The negative shows a full range of tones throughout the image. The numbers in the film's rebate are dark, crisp and clear.

Correct exposure, under-development

▲ The negative is thin and lacks contrast, although there is still detail in the shadow areas. The numbers in the film's rebate are too light.

Underexposure, correct development

▲ The negative is generally too thin and the shadow areas are badly defined. The numbers in the film's rebate are crisp and clear.

Underexposure, under-development

▲ The negative is far too thin and it lacks any contrast. The numbers in the film's rebate are too light.

Overexposure, correct development

▲ The negative is generally too dense. The shadow areas are blocking up, or merging. The numbers in the film's rebate are crisp and clear.

Overexposure, under-development

▲ The negative looks correct at first sight, but detail is not as sharply defined as it should be. The numbers in the film's rebate are too light.

leads to a dense negative, in which the image appears to be very contrasty.

Under- and overdevelopment can be confused with under- and overexposure, but there is a difference. Shadow areas (the light areas of the negative) will be clear if the image has been underexposed, but will still register if the exposure was correct, even if the negative was underdeveloped. Overexposure gives a coarse-grained negative.

Correct exposure, over-development

▲ The negative is too dark and contrasty overall. The numbers in the film's rebate are also too dark and they are tending to spread out and fatten up.

Underexposure, over-development

▲ The negative looks correct at first sight, but shadow areas are lacking detail. The numbers in the film's rebate are too dark and tending to spread out.

Overexposure, over-development.

▲ The negative is far too dense and contrasty. The numbers in the film's rebate are also too dark and they are tending to spread out.

Processing faults

The worst fault is when there is no image at all. Completely clear film means that it has not been exposed. If there are no edge numbers either, it has not been developed. Totally black film means that it has been exposed to light, in the camera or darkroom.

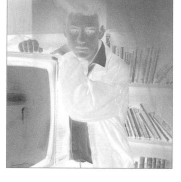

◄ Fogged film, due to light getting into the cassette. The resulting streaks of light have developed as dark areas on the negative.

◄ The streaks on this negative are sections of the film that have been exposed but not developed. This is caused by not having sufficient developer in the developing tank.

◄ The lines on this negative are stress marks. They have been caused by the film kinking as it was forced into the developing tank spiral.

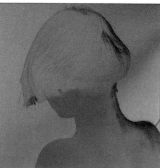

◄ The marks on this negative are due to the emulsion beginning to break up. This can occur if there is a huge difference in the temperatures of the different solutions.

Making a print

THE PROCESS OF MAKING a black and white print is dependent on you working from a reverse-toned negative. This is because areas of the film emulsion struck by light, after development, darken in proportion to the strength of the original illumination. This is why negatives are dark where the original subject was light, and vice versa.

When making a print, a negative is projected on to a piece of sensitive paper and the image is formed in the same way as when a camera lens projects an image on to film. Here, however, the dark areas of the negative inhibit the transmission of the light, and so shield those parts of the paper. When developed, these areas are light in tone. What you are actually making is a negative of a negative – a positive.

Unlike film, black and white printing paper is insensitive to red or orange light. This allows you to use a safelight of one of these colours, as long as it is not positioned too close to the enlarger or the processing dishes. But before making a print, though, you should first make a test strip to assess the correct exposure under the enlarger.

FOCUSING THE ENLARGER

1 First place the negative into the enlarger's negative carrier and push the carrier into the enlarger. The negative should be placed shiny side up, but with the image upside down.

2 Turn the room light off and the enlarger on. Adjust the height of the head to produce the required size of image on the easel. Adjust the focusing control. Use a focus magnifier to check.

3 Focus at the enlarger lens's widest aperture, but then close down two or three stops before making the exposure. This will give greater depth of field and so help correct any focusing inaccuracy.

EXPOSING THE TEST STRIP

1 Turn off the enlarger and, with the safelight on, take a sheet of paper out of its sealed bag and place it in the easel, shiny side up. Turn the timer and enlarger on at the same time to begin exposing.

2 After 2 seconds, cover a small strip of the paper, using a piece of opaque card. After another 2 seconds, cover another strip of the paper and continue in the same way every 2 seconds.

3 Continue until you have covered the whole sheet of paper. This means that you have now exposed successive strips of the paper for, 2 seconds, 4 seconds, 6 seconds, 8 seconds, and so on.

PROCESSING THE TEST STRIP

The next stage is processing the test strip, which is carried out in dishes by the light of the safelight. The chemistry for this is much the same as that used for film – developer, stop bath (or wash) and fix. The stop bath and fixer used for film development can also be used here, although different dilutions are usually recommended. It is best, however, to use a developer formulated specifically for prints. This can be kept for short periods and reused for later printing sessions.

1 Slide the paper quickly and evenly under the surface of the developer, ensuring that the whole area is covered.

2 Throughout development, gently rock the dish. The image will soon appear on the paper and strengthen rapidly.

3 After the recommended time, remove the print from the developer, using the print tongs to protect your fingers.

4 Allow excess developer to drain into the dish, then slip the print into the stop bath or water dish for the recommended time.

5 Drain the print and place it into the fixer for the recommended time. After 1 minute, you can turn on the room light.

6 Wash the print in running water, or place it in a dish or bucket of water and transfer to running water as soon as possible.

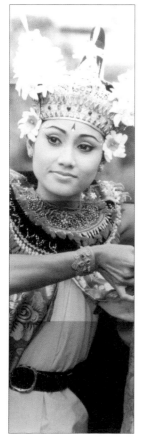

◀ **THE TEST STRIP**
You have now exposed and printed your test strip. There is no need to dry it in order to assess it, but you should make the assessment in white light or daylight. The test strip will show the image with different bands of density, each corresponding to the length of time it was exposed under the enlarger light.

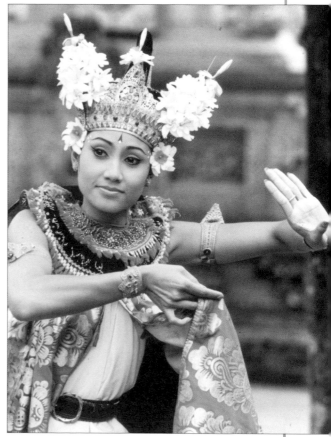

▶ **THE FINISHED PRINT**
Choose the strip that exhibits the best range of tones and expose the complete print for this amount of time. Process the final print in exactly the same way as you did the test strip.

Choice of paper

PRINTING PAPER is not all the same. Black and white paper is available in different contrast grades and surface finishes designed to give a range of different effects.

The two most widely used surfaces are glossy and matt. When you begin, you will probably use glossy, because this produces a richer black and a sharper-looking image than matt-finish types.

Most printing papers today are resin coated. These papers have a special finish that prevents liquid soaking into the paper base, and so are quicker and easier to process. Traditional papers are fibre based. These give a richer range of tones, but they take longer to process, wash and dry.

Paper grades are designated by numbers, usually 0-6. Grade 2 is normal. Lower numbers are 'softer', meaning that the image will be less contrasty and contain an extended range of mid-tones. Higher numbers are 'harder', making them more contrasty since some or, depending on the grade, many of the mid-tones are omitted. 'Multi-contrast' papers are capable of giving a range of different contrasts on the same sheet of paper, depending on the way the enlarger light is filtered. Magenta light makes the paper harder, while yellow light makes the same paper softer and less contrasty.

◀ A correctly exposed and correctly developed negative. The same negative was used to make all three prints shown on this page.

▲ Printed on a soft grade of paper, the correctly exposed and developed negative produces a low-contrast print.

▲ With a medium or normal grade of paper, the print exhibits a full range of tones from black to just a little lighter than the base of the paper.

▲ On a hard grade of paper, the same negative produces a high-contrast print with a restricted range of grey tones between black and white.

◀ **CONTACT SHEET**
To decide which negatives to print, and how, make a contact sheet by placing strips of negatives, emulsion-side down, in contact with a sheet of printing paper. Place a sheet of clean glass on top to hold the negatives flat and expose them under the enlarger. Make a test strip to determine exposure and then process the paper as normal (*see pp. 134-5*). Comparing negatives like this will also help to show you which grades of paper might be best for each particular picture.

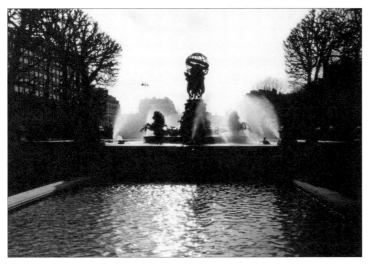

A high-contrast negative (*above*) could produce a fairly normal print on a soft grade of paper. Alternatively, it can be printed on a hard grade to produce a more striking, high-contrast print (*left*).

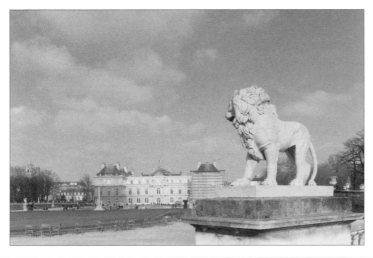

A low-contrast negative (*above*), printed on to a soft grade of paper, reduces the range of intermediate tones in the final print and leads to this pleasing low-contrast type of result (*left*).

137

Composing on the baseboard

PHOTOGRAPHERS WHO USE commercial processing laboratories, instead of doing their own developing and printing, miss out on all the creativity of darkroom work.

In the darkroom, the composition of the original image on the negative can be subtly changed, depending on how the picture is cropped or which portion of the negative is chosen for enlargement. In many cases, the same negative can produce two or three very different prints – each good in its own terms – depending on how it is handled at the printing stage.

In this regard, darkroom processing and printing can be every bit as original and creative as the initial photography.

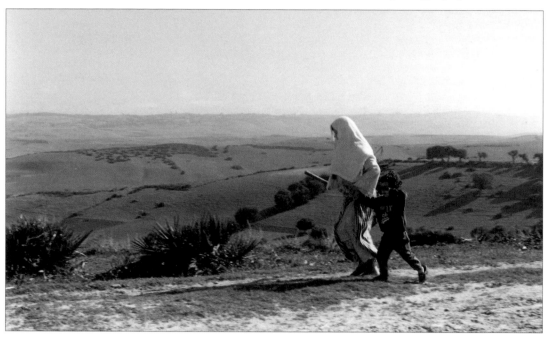

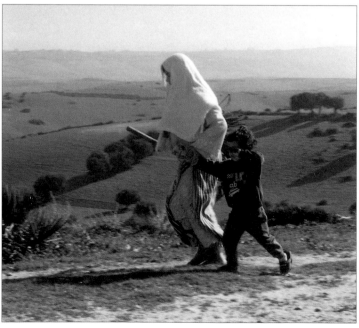

▲ TRADITIONAL CROP
Here, a negative has been cropped with the emphasis on traditional picture composition, placing the figures on the right of the frame and thus leaving space on the left for them to move into.

◄ CREATING EMPHASIS
Here, the same negative has been recomposed on the enlarger baseboard to give additional emphasis to the figures themselves. This has been achieved by removing much of the surrounding landscape.

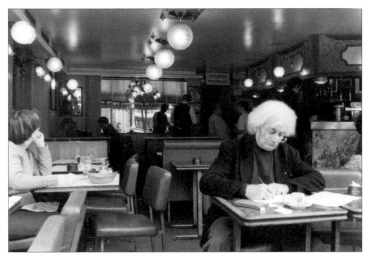

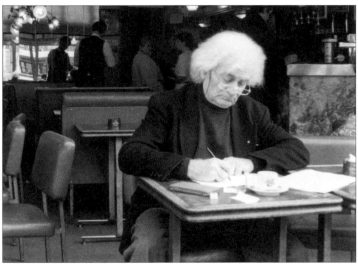

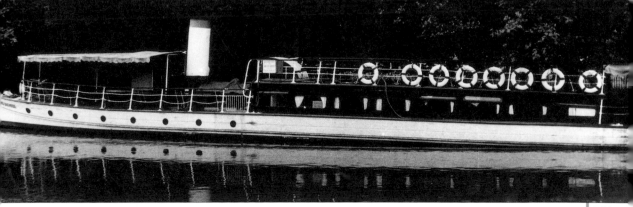

▲ VERTICAL CROPPING
Not every subject fits comfortably into the traditional format of a camera negative. Tall subjects can be cropped and the prints trimmed to make a much narrower picture than normal, thus emphasizing the shape of the subject.

▲ REMOVING CLUTTER
You can often improve the composition of a picture simply by selecting the best area for enlargement. In the original picture (*top*) too much extraneous detail has been included. The man at the café table is lost in a distracting background and the eye wanders all over the frame, taking too much notice of unimportant aspects. In the second picture (*above*) the picture has been cropped and enlarged to give emphasis to the man, who is the principal subject of the picture.

▼ HORIZONTAL CROPPING
In the same way as that demonstrated in the example above, subjects that demand more of a horizontal, panoramic format can be easily cropped under the enlarger to make a longer picture, one with less height than usual.

Shading and burning-in

Until now, the assumption has been that the test strip (*see pp. 134-5*) helps to determine the best exposure time for the whole print. In fact, with many pictures it is a good idea to give different parts of the paper very different exposures.

The test strip, for example, might indicate that the sky reproduces better with less exposure than the ground, whereas a bright white wall of a building needs more exposure than its surrounding landscape in order to retain detail in the brickwork. That's the time to start dodging and shading.

▲ TOOLS OF THE TRADE

Shading (or dodging) and burning-in are ways of controlling the tone of a print. By holding a piece of card over some of the paper for part of the exposure you lighten the tone of that area. To burn-in, cover all of the paper partway through, except for the part you want darker.

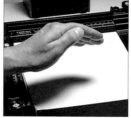

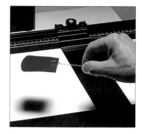

▲ TECHNIQUES

Some printers use their hands, others pieces of card, to make shadows over the paper to locally reduce exposure times.

No matter which technique you use, keep the shader constantly moving to prevent abrupt differences in tone appearing.

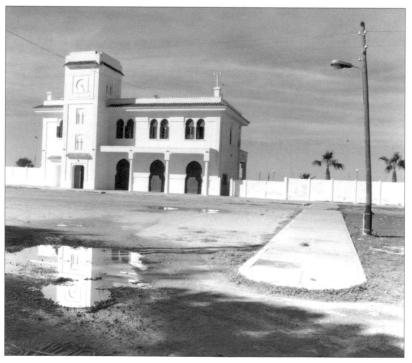

◄ BEFORE AND AFTER

These two pictures show the types of difference you can achieve by reducing or increasing the density of local areas of a print. All of the first print (*top left*) was printed at a single exposure and there is a great range of tonal response throughout the image. The larger print (*left*) has had very different treatment. The bottom of the print received the same exposure as the first. It was then covered with a piece of cardboard while the rest of the image received 50 per cent additional exposure to burn extra detail into what were formerly rather bleached and empty parts of the picture.

Multiple printing

MULTIPLE PRINTING involves printing parts of two or more negatives on the same sheet of paper. The technique can be used for something as simple as adding a sky from one negative to a landscape from another. It can also be more extreme, with several negatives being used to build up a composite and surreal final print.

If the area into which you want to add a second image is dark on the first negative, therefore printing light in the final picture, you can simply expose two negatives in succession on the same sheet of paper. If, however, the combination involves more complicated images, you will need to mask certain areas of the first print in order to leave space for the appropriate part of the second image to be printed into.

First, size up the various negatives to be used on a plain sheet of paper, sketching in the way each is going to fall in the finished picture. Next, make test strips for each negative to determine the different exposure times needed. Then use the master sketch to make the masks that you will use to block certain parts of each picture during each of the exposures, much like the shading and burning-in techniques (*see opposite*).

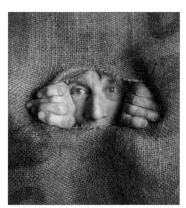

▲ **FIRST ORIGINAL**
With this sized up, a mask was cut from the middle of a piece of card to the shape of the hole.

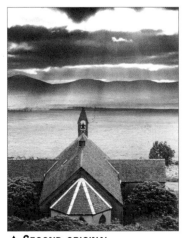

▲ **SECOND ORIGINAL**
The scene into which the face is to be inserted. This was exposed with the circular mask held over the central part of the sky.

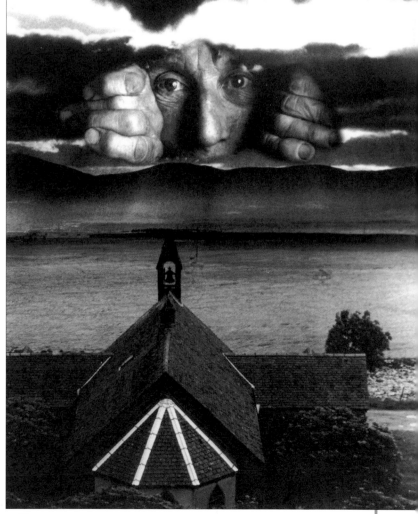

▲ **THE FINAL RESULT**
The shape left when cutting the original mask was used to cover all but the shape of the hole, through which the first negative was printed.

Sandwich printing

SANDWICH PRINTING is similar to, and sometimes confused with, multiple printing (*see p. 141*), although they are different techniques producing different results. To make a sandwich print, two negatives are placed together in the enlarger's negative carrier and the resulting combination is then printed as normal. It is a straightforward technique, but the original negatives need to be chosen with great care.

To work best, one negative should have sharply delineated areas of light and dark, so that the image of the second negative can record through the clear areas of the first. It is best if one of the images is of some recognizable subject, such as a landscape or a portrait, while the other, which will overlay the first with its texture, is more abstract.

Often it is a good idea to shoot the secondary images specifically for the purpose. Any textured surface tends to work well: bricks, stonework, basketweave, even a dense pattern of tree branches against a clear sky.

Because the sandwich of two negatives is necessarily dense, it helps if the initial images are a little underdeveloped to make them thinner than usual. It also helps to place the negatives emulsion to emulsion, so that the actual images are more in the same plane and therefore easier to focus together.

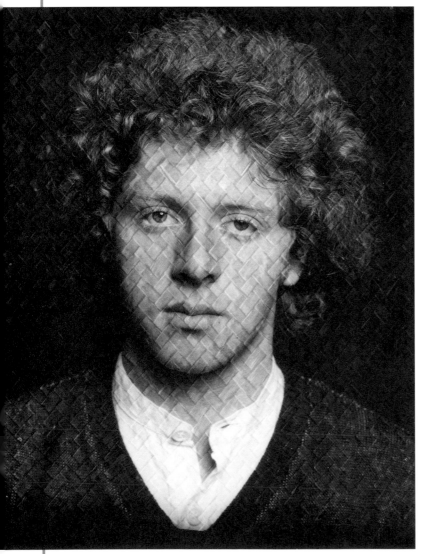

◀ **TEXTURE OVERLAY**
To make this sandwich print, two negatives were combined in the enlarger's negative carrier. The first was a standard studio portrait; the second was a close-up of the woven pattern on a straw basket. The two slightly underdeveloped negatives were placed in contact and then exposed and processed in the normal way (*see pp.134-5*).

Using lith film

LITH FILM is available in 35mm lengths or in different sizes of sheet film. It is orthochromatic, which means that it is insensitive to red light, and so can be used in the light of a red darkroom safelight.

When processed correctly, lith film gives a 'soot and whitewash' effect, recording only dense black and pure white and eliminating all the intermediate tones of grey. In order to achieve this stark, contrasty effect, it is best to process the film in its own special lith developer. Failing that, process it in print, rather than film, developer.

Lith film is used to make intermediary negatives for various specialist darkroom effects and exposures, followed by processing in much the same as normal printing.

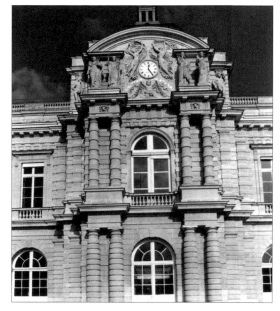

▲ NORMAL RESULT
Made from a normal negative on normal printing paper, this print shows a full range of tones.

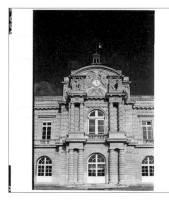

▲ FIRST INTERNEG
The same negative, contact printed on to lith film to produce a harsh, positive image on film.

▲ SECOND INTERNEG
The positive image, contact printed on to another piece of lith film to make an even harsher negative.

▲ FINAL RESULT
Print made on hard-grade printing paper, using the second interneg (*left*).

Solarization

SOLARIZATION, OR MORE ACCURATELY the Sabattier effect, describes a picture that has an intriguing mix of positive and negative aspects. It is achieved by exposing film or paper to white light partway through development. This results in a darkening of the undeveloped areas of the image and a reversal of some of the tones. Also, a strong line appears between the borders of what should have been the light and dark areas.

The simplest, although a rather hit-and-miss, way of producing a solarized image is to expose a print in the normal way, and then briefly flash a white light over the developing dish halfway through development. You then continue development for the prescribed time, before washing and fixing the print in the normal way.

A better technique is first to contact print a negative on to lith film (*see p. 143*). Develop this normally for half the correct development time, and then expose the film, while still in the developer, to white light from the enlarger for the same period as the original exposure. Then continue development and the other processing steps normally.

A test strip can be made at the start to determine the best exposure on to the lith film. The solarized negative can then either be printed in the usual way, or contact printed with another sheet of lith film to make an intermediate negative (interneg) that shows the original tones reversed. If you are making a print from this interneg, a hard grade of paper (*see pp. 136-7*) usually produces the best results.

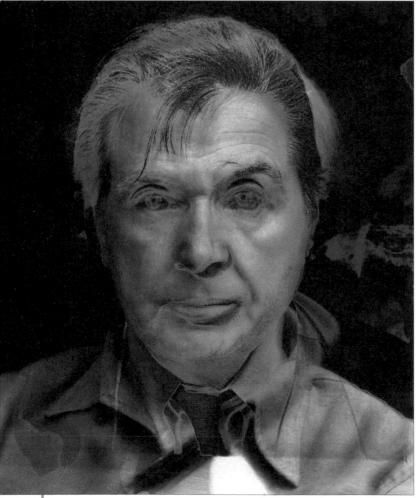

◀ **SOLARIZED RESULT**
In this solarized print you can see that some of the image has remained normal in appearance while other parts have been partially reversed. Note how the technique introduces a sharp line, known as a Mackie line, between light and dark tones in some places.

Posterization

POSTERIZATION TAKES LITH FILM techniques a step further. With posterization, the image still shows a stark black and white effect, but this is combined it with just a few well-defined intermediate shades of grey.

To prevent the process becoming too complicated, it is best to make a posterized print showing just three tones. Begin by exposing a conventional negative on to three pieces lith film (*see p. 143*). One film should be overexposed, one normally exposed and the one underexposed. By doing this, one of the films will favour only the shadows,

another the mid-tones and shadows, and the final film will favour only the highlights.

After processing, you will have what is known as 'density separations' of the original image. Posterization depends on you printing each film in turn in exact register with the others. To ensure this, place the films on top of each other and punch holes through their rebates. These holes line up on a special pin register within the negative carrier. When printing them on to the paper, determine an exposure for each that will produce only a mid-grey to prevent the print being too dark.

◄ SEPARATION 1
The first lith negative was exposed to record the pale tones only.

◄ SEPARATION 2
The second lith negative was exposed to record the mid-tones and shadows only.

◄ SEPARATION 3
The third lith negative was exposed to record the dark tones only.

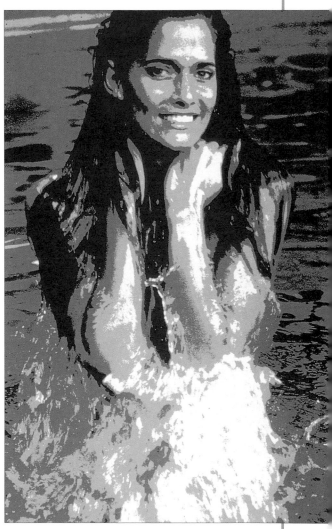

▲ FINAL RESULT
This image was made by printing the three separations (*left*) on to a piece of normal-contrast paper. Each separation was exposed to produce a mid-grey tone only.

Spotting and retouching

EVEN THE MOST METICULOUS printer can end up with images that need retouching. Specks of dust adhering to the negatives as they dry print as white dots, while scratches on the negative emulsion might appear as fine black lines. But with a little practice you can can disguise most of these.

For prints on matt paper, you can use a soft lead pencil to retouch white marks. For glossy prints, or those made on resin-coated paper, you need a tube of black watercolour paint or special retouching paint.

Always use the finest brush available (a size 0 or 1 is ideal) and build up the area to

be retouched with a series of minute dots, overlapping them for a darker tone. For black marks, use white paint, or a sharp scalpel to scratch the surface of the print gently. This is a technique that works best on fibre-based rather than resin-coated paper.

◀ **USING A BRUSH**
Use a fine brush to build up gradually the area to be retouched by making a series of minute dots. Do not try to paint the fault out with larger brush strokes, since the result will be crude and obvious.

▶ **USING A SCALPEL**
For black specks, use a scalpel to scrape away gently the surface of the paper's emulsion before building up the tone again..

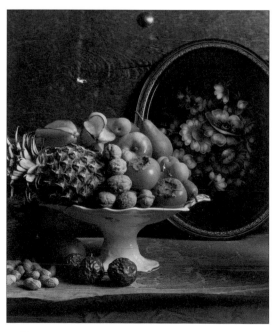

▲ **ORIGINAL PRINT**
Just as it came from the processing tray – a print in need of retouching to remove the prominent dust speck on the background wood.

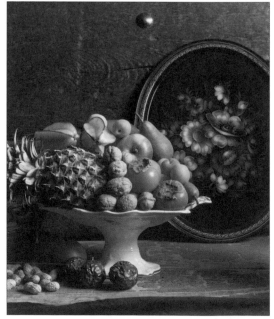

▲ **AFTER RETOUCHING**
This is the same print after retouching with a fine brush and watercolour paints. The dust speck is now completely invisible.

These days, it is becoming increasingly common to find print retouching carried out electronically rather than manually. This is something that started with the book and magazine printing industry using large and very expensive equipment. As small desk-top computers have become more powerful, however, and the software more sophisticated, both professional and amateur photographers are learning how to manipulate their images in this way.

The print to be retouched is first scanned into a computer using a laser, and the image is then stored digitally. It is then possible, using specialized software, to redraw parts of the image. This means that any imperfections or blemishes can be removed on screen, pixel by pixel if necessary, before the image is output to film once more.

▲ CRACKED WITH AGE
This early 20th-century photograph, for which no negative now exists, has been damaged by years of neglect. It makes a prime candidate for computerized retouching.

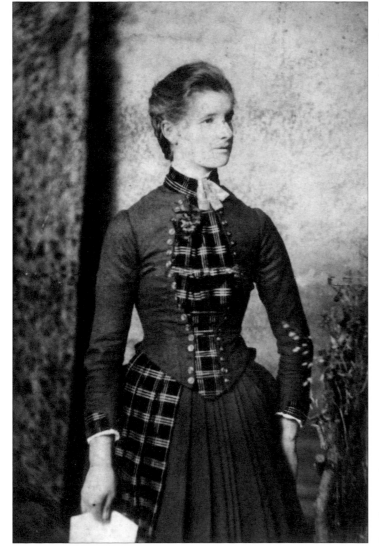

◄ AFTER RESTORATION
The same picture as above, after being digitally laser scanned, stored and retouched with a computerized graphics programme, probably looks better now than it did when originally taken.

Toning

PERHAPS THE BEST-KNOWN toner is sepia. This is the substance that produces the brown images we associate with early photographic processes. But sepia is not the only toner – black and white prints can be coloured red, blue, and green . . . and many more colours besides.

Toning works quite simply by converting the silver that makes up the black, and all the intermediate tones, of an image to a chemical dye of a specific colour. There are several methods of toning a black and white print, but the most common are the single-solution and the two-bath methods.

In the first method, the print is immersed in a single solution that replaces the silver in the print with a chemical dye of a different colour. In the second method, the print is immersed in a chemical that initially bleaches out some or all of the silver image. This is then re-darkened to form a colour using the toner solution.

All toning processes can be carried out in normal room lighting.

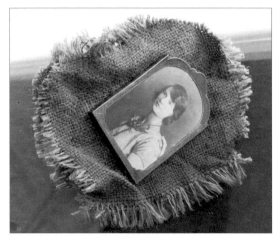

▲ **THE ORIGINAL IMAGE**
This is the original black and white print before beginning a sepia-toning process – a two-bath method.

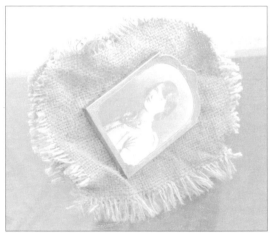

▲ **AFTER BLEACHING**
The original image has been bleached to convert the black silver to silver bromide, which can then be toned.

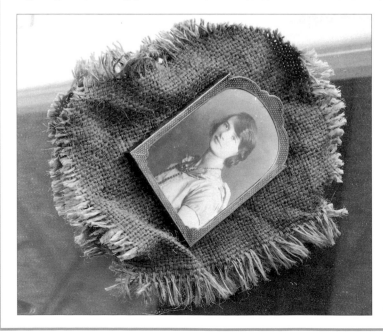

◄ **AFTER TONING**
After immersion in the sepia toner, all the silver-based areas of the image have been rendered in various shades of brown. The coloration is now very much in keeping with the actual content of the photograph, which a decidedly old-fashioned feel to it.

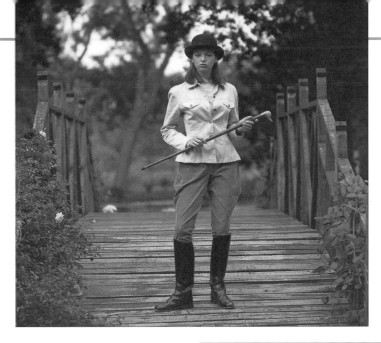

◀ **BLUE TONER**
This striking image is the result of
using an iron metal toner solution.
The length of time the print remains
in the toner determines the strength
of colour achieved.

▶ **RED TONER**
Red toning has transformed this
black and white print. This type of
effect is possible using a nickel
toner solution – another type of
metal toner.

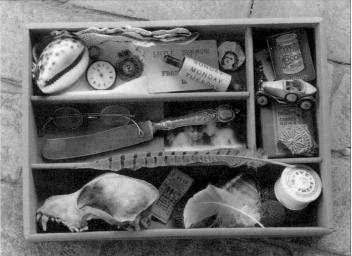

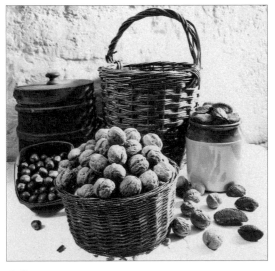

▲ **SILVER PAPER BASE**
A similar effect can be achieved by using specialized
printing papers, which have coloured bases. This print
was made on a sheet of silver-based paper.

▲ **GOLD PAPER BASE**
This image was printed on gold-based paper. Whereas
toning affects the blacks and greys, this technique
retains the tones and alters the paper's base colour.

Hand colouring

IN AN AGE when colour prints are the norm, it seems perverse to hand colour black and white images. However, hand colouring – once the only way to produce colour photographs – has today become an art-form.

It is, of course, possible to colour an entire photograph, but a more creative effect can often be achieved by leaving most of the print in its original form and merely colouring selective areas – the eyes or lips in a portrait, for example.

Because of its plastic base, resin-coated paper is not suitable. Watercolours can be used on a damp print, while oil colours work best on dry prints. Even felt tip pens can be used for hand-colouring purposes.

▲ THE ORIGINAL IMAGE
This image makes an ideal subject for hand colouring.

▲ SOAK THE PAPER
Before using water-based paint, soak the print and then work on the image while it is still damp.

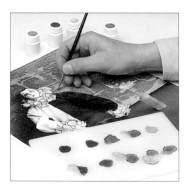

▲ BUILD UP THE EFFECT
Work on small areas of the print at a time and think about colouring only small sections.

▶ THE FINAL RESULT
This partially hand-coloured result has real impact.

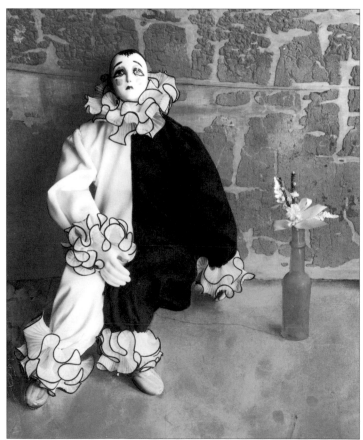

Dry mounting

FOR THOSE CONTEMPLATING entering their pictures in exhibitions, or perhaps displaying them on a wall, mounting the print is essential. There are several ways of doing this. You can spray an even coat of a dry-mounting medium on the back of the print, and then press it down on to a piece of stiff card. A better method, however, is to use heat-sensitive dry-mounting tissue.

This tissue-thin material has a coating of shellac on either side covered by a thin layer of wax. The tissue is placed between the print and the mount and, when heat is applied, the wax melts, releasing the gum and bonding the print and mount. The print can be flush-mounted so that it covers all the mount, or it can be positioned centrally on the mount, leaving a border all around.

A dry-mounting press can be used. This not only applies the necessary heat, it also exerts an even pressure over the entire surface to be bonded, thus keeping the print completely flat against its mount. For those on a budget, or if only an occasional print is to be mounted, an ordinary domestic iron, set to a low heat, can be used for the purpose.

1 Place the tissue on the back of the print. Use a tacking iron to attach it to the corners of the print.

2 With the print face up on the mount, lift each corner and tack the tissue to the mount.

3 Place tracing paper over the print and apply heat to the whole surface at the iron's lowest setting.

4 Use a metal ruler and a sharp blade to trim the print and mount together for a flush effect.

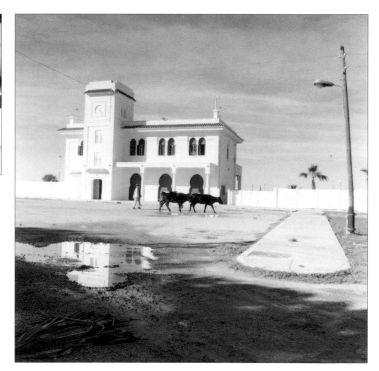

▶ **READY FOR THE SHOW**
Here is the final print, mounted and ready to be exhibited or hung on the wall at home.

Filing

THE MORE PICTURES YOU TAKE, the more you will need a good negative filing system. There is nothing more frustrating than searching for hours through piles of negatives for one specific image.

Never leave negatives in rolls. Cut them into strips and store them in the plastic or paper sleeves that are sold for the purpose in most camera stores. Each holds a complete 36-exposure film in strips of six. These, in turn, can be stored in ring binders.

Before filing, make a contact sheet from each film and place this either in the ring binder immediately next to the corresponding negatives, or in a separate file. You can then set up either a simple card index system or a database on a computer that will help you find negatives in the fastest possible time.

List each picture in as many different ways as possible, each with its own card in the index, or as a separate entry on the database. You might, for example, list a typical holiday shot under the name of the place, the person in the picture, or even the photographic technique used for taking it. Then give each entry a code number. This should consist of a number for the place the sheet occupies in the ring binder, followed by the frame number of the specific negative. As your files grow, you can add extra ring binders and add an extra code for each one, perhaps in the form of a letter.

Filing is a chore, but it is something that should never be ignored. File all films as soon as they are processed, and keep them in a cool, dry area away from chemical fumes.

▲ RING BINDERS
Negatives are stored in strips of six in special sleeves, which are kept in a ring binder with coded pages.

Presentation

GOOD PRESENTATION is essential. Mount your prints as already described (*see p. 151*). Prints can be positioned centrally on the mount, or offset with perhaps one-third of the space at the top and two-thirds at the bottom. Once the print is mounted, you can then try out different frames.

When hanging a picture, place it on a wall adjacent to, rather than opposite, a window. If you don't, reflections in the glass will lessen the impact. (You can buy non-reflective glass, often used in exhibitions, but it is expensive.) Also bear in mind that harsh, direct sunlight will bleach the image over time.

▶ Mount your pictures to complement the subject matter. Here a red mount has been chosen to evoke the colourful make-up and lively expression of the clown.

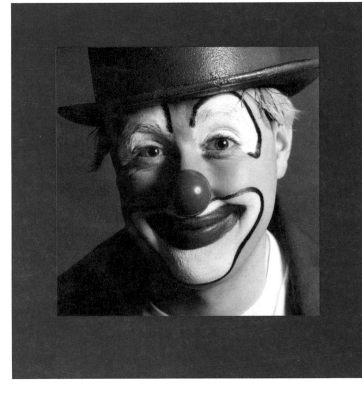

▲ Mounting board is available in a variety of colours, so don't be afraid to stray from traditional black or white.

153

Glossary

Angle of view The amount of a scene of subject that can be encompassed by a particular lens focal length, or a focal length setting on a zoom lens. A wide-angle lens has a greater angle of view than a telephoto lens.

Aperture A gap of variable diameter formed by a series of overlapping metal leaves set within a lens. The size of the aperture is controlled by a ring on the outside of the lens marked in f numbers, or automatically by some form of camera autoexposure system. The size of the aperture determines the intensity of light reaching the film.

ASA An abbreviation for American Standards Association. A system of rating the speed, or sensitivity to light, of film, now replaced by the internationally agreed ISO system.

Burning in Increasing the amount of exposure received by a part of a print in order to darken that part of the image.

Chromogenic Photographic films or papers that form coloured dyes during processing.

Contact sheet A sheet of images the same size as the negatives, produced by placing the negatives in contact with printing paper and exposing them to light. Used to select images for enlargement.

Contrast The difference in brightness between the brightest highlights and deepest shadows in a subject, negative or print.

Cropping Selectively enlarging an image so that unwanted parts of the subject are not recorded on the printing paper. Cropping also refers to the selection process at the picture-taking stage when the camera is lined up so that unwanted parts of the scene are not included in the viewfinder.

Depth of field The zone of acceptably sharp focus that extends both in front of and behind the point of actual focus. Depth of field is variable, increasing as focal lengths become shorter, apertures smaller and focal distance farther from the camera.

Developer A chemical solution used to convert the latent image on exposed film or photographic paper into a visible image. Many different types of developer are available: universal developers are suitable for developing both negatives and prints, high-energy developers for increasing emulsion speed, high-contrast developers for lith materials, and so on.

Development The chemical treatment and mechanical procedure that converts a latent photographic image into a visible image.

Dodging Decreasing the amount of exposure received by a part of the print in order to lighten that part of the image. Also known as shading.

Dry mounting Attaching a print to a piece of backing board by inserted a layer of adhesive shellac between print and board and subjecting it to heat.

Emulsion The light-sensitive coating on film and photographic paper consisting of silver halide grains suspended in gelatine.

Exposure The total amount of light reaching the film or photographic paper. In the camera, this is determined by the size of aperture and the shutter speed. In the darkroom, exposure is the result of the size of the aperture of the enlarging lens and the length of time the enlarger is switched on.

Fixer A chemical solution used in film and print processing. The action of the fixer converts unexposed and undeveloped silver halides into water-soluble salts that can be rinsed away, thus making the image stable in white light.

f numbers A series of numbers found on the aperture control ring of a lens. Turning the ring to the next larger number (from f5.6 to f8, for example) halves the area of the aperture and so halves the intensity of light reaching the film (or paper with an enlarger lens). Also known as f stops, which gives rise to the expression 'stopping down' – meaning to make the aperture smaller by selecting a higher f number setting.

Fogging Subjecting film or photographic paper to non-image-forming light. This creates an area of uniform density. The same effect can be caused by exposing the film or paper to certain chemicals or chemical fumes.

Grain The visual appearance of the individual clumps of silver halide crystals making up the photographic emulsion. Fast, high-ISO films are inherently more grainy than slow, low-ISO films. Grain becomes more apparent the more a negative is enlarged and also in areas of a print that have a neutral tone.

Hand colouring Applying colour – watercolour, oil, acrylic and so on – to a photographic image. Hand colouring is usually applied to a black and white print, the density of which may be reduced by the application of a special bleaching agent.

High key An image in which the tones are predominantly light. The effects of a high-key image can be enhanced by slight overexposure.

ISO An abbreviation for International Standards Organization. An internationally agreed system of rating the speed, or sensitivity to light, of film, which has replaced the ASA system. A doubling of ISO number (from 200 to 400, for example) indicates a doubling of film speed.

Lith film An extreme high-contrast film, which, when used in conjunction with a special lith developer, produces images that consist of either black or white, with no intermediate shades of grey.

Low key An image in which the tones are predominantly dark. The effects of a low-key image can be enhanced by slight underexposure.

Mask Any opaque material held between the enlarger lens and printing paper to block the path of image-forming light. Masks are commonly used in multiple printing so that different negatives can be projected by the enlarger on to the same piece of printing paper without the images overlapping and becoming confused.

Multiple printing A print composed of images from more than one negative. Masks are used to shield parts of the printing paper that have already been exposed each time a new negative is projected down from the enlarger.

Negative A film image in which the subject tones or colours are reversed. A black and white negative will have dense areas of tone corresponding to bright subject highlights, and areas of clear film corresponding to dense subject shadows.

Overexposure Allowing the film or photographic paper to receive too much light, giving rise to a pale-toned result.

Paper grade Describes the contrast-recording ability of photographic paper. Grades 0-1 are considered soft; 2-3 are normal; 4 and above are hard.

Posterization A print that contains areas of clearly demarcated flat tones, as opposed to natural-looking continuous tones.

Print A positive image on paper, producing by shining light through a negative.

Retouching Using dyes or pigments, usually with a fine brush, to remove blemishes from a negative or print.

Sabattier effect A darkroom technique in which a part-developed image is re-exposed to white light to produce a part-negative, part-positive result.

Safelight A low-wattage darkroom light filtered so that its colour will not affect the photographic emulsions being used. Although light output is usually very low, it is sufficient to allow the darkroom to be used conveniently.

Sandwich printing Combining two or more film images in the enlarger and printing them simultaneously on to one piece of photographic paper.

Shutter speed The length of time the camera's shutter stays open, allowing light from the lens aperture to affect the film. The shutter speed dial is calibrated in speeds of fractions of a second, or multiples of complete seconds. Changing the dial to the next setting either doubles or halves the length of time the shutter remains open.

Solarization Causing the tones of a photographic image to reverse through massive overexposure. This term is often incorrectly applied to the Sabattier effect.

Speed Refers to the light sensitivity of film or to the widest maximum aperture a particular lens has to offer.

Spotting An aftertreatment for negatives or prints in which small dark or light marks are removed using dyes, pigments, inks or pencils.

Stop bath A chemical solution used to halt the action of film or paper developer when the right image density has been reached. The image still needs to be treated in fixer to make it stable.

Test strip A strip of printing paper with a range of exposures, used as an exposure guide for making an enlargement.

Tonal range The shades of grey between black and white contained in a negative or print.

Toning Using chemicals to change the colour of a black and white image.

Underexposure Allowing the film or photographic paper to receive too little light, giving rise to a dark-toned result.

Index

speed enhancement 23
Developing a film 128-31
Diffusing light (*See* Light, softening)
Dimming light 12
Distance (*See* Perspective; Three-dimensional effects)
Dodging 101, 140, 154
Domestic lighting (*See* Artificial light)
Double exposure 10
Drama, in photographs 100-1, 116
Dry mounting 151, 154
Dusk light 100, 103

E

Emulsion 154
Enlargement
 degrees of enlargement 22
 for informal portraits 68
 selective (*See* Cropping)
Enlarger 129
 focusing 134
Equipment for darkrooms 128-9
Exposure 154
 (*See also* Double exposure; Overexposure; Underexposure)
Exposure meters, misleading readings in subdued light 96
Eyeline 26
 (*See also* Leading the eye)

F

F numbers 154
Face, framing 53
Faults, correcting 146-7
 in processing 133
Feet, photographing 74
Field, depth of (*See* Depth of field)
Figures, groups of 49
Filing system, for negatives 152
Fill-in light 77
Film speed 155
 and contrast 18
 for drama 100
 and grain 22, 87
 (*See also* ISO numbers)
Filters, for black and white photography 10-11, 36-7, 106, 107
Fixing a film 128, 131, 154
Flash
 for floodlighting 84

for highlights 38
for interiors 122, 123
and shutter speed 32
for still lifes 40, 41
to freeze movement 32
Flat-on viewpoint 31
Floodlighting 84
Focus
 for frames 28-9
 (*See also* Depth of field)
Focus of interest, in landscapes 102
Fog (*See* Misty light)
Fogging 133, 154
Foliage, and filters 11, 36, 37
Foreshortening 52
Formal portraits of children 73
`Found' still lifes 46-9
Frames 28-9, 65
 for buildings 115, 119
 foreground as 90, 91
 for portraits 50, 53
Freezing movement 32, 33, 108

G

Gold paper base 149
Grade, of paper (*See* Paper grade)
Grain 22-3, 154
 accentuating 101
 for children's portraits 72
Green filter 11, 36
Groups of figures, photographing 49

H

Hand colouring 150, 155
Hands, photographing 25, 74-5
High key 20-1, 155
High-contrast film (*See* Lith film)
Highlights, using flashgun 38
Historical character, as subject of still life 44
Horizontally framed images 94-5, 139
Human form 78-85
 people in a landscape 112-13
 (*See also* Feet; Hands; Nudes; Portraits; Skin)
Humour, in photography 60, 113

I

Idealized landscape 102-3
Image grain (*See* Grain)

Informal portraits 68-9
Intensity, light, extreme 67
Interiors 12, 122-3
International Standards Organization numbers (*See* ISO numbers)
ISO numbers 155
 (*See also* Film speed)

K

Key (*See* High key; Low key)

L

Landscapes 89-121
 examples 18, 20, 21, 27, 29, 105
 texture in 24
 (*See also* Sky; Urban landscapes)
Leading the eye 26-7, 55, 60, 103
Lens
 aperture 154
 choice for architectural photography 120
 for framing subject 28
 (*See also* Angle of view; Telephoto lens; Wide-angle lens; Zoom lens)
Light
 best for landscapes 102
 for darkrooms (*See* Safelight)
 differences according to time of day 7, 96-7, 100, 102, 103, 116, 118, 119
 misty 20, 89, 94, 96-7, 110
 mixing natural and artificial 10, 41
 north, advantages 58
 softening 78, 83
 stormy 21, 101
 subdued 96-7
 using what is available 84, 86
 waiting for ideal 47
Light sources 9-10
 artificial light 9-10, 122
 candle light 86, 87
 car headlights 99
 (*See also* Daylight)
Light tones 16-17
 (*See also* Overexposure)
Lightening prints (*See* Dodging)
Lines
 on negative 133
 to lead viewer's eye 26, 27
Lith film 143, 144, 145, 155
Long lens (*See* Telephoto lens)
Low key 20-1, 155

Acknowledgements

The author would like to thank Roger Bristow and Phil Kay for styling and designing the book; Jonathan Hilton, John Wade and Sarah Hoggett for editorial work and assistance on the text; and Jenny MacIntosh for her work as photographic assistant.

Studio photography and darkroom facilities were provided by Simon Logan and Harry Mears of Saffron Photography Ltd, with assistance from Simon Nicol. The illustrations of negative faults were produced by Peter Elgar, the posterized and multiple prints by Harbutt and Grier, and the diagrams of darkroom set-ups by Craige Quainton. Special thanks are due to KJP for their very generous loan of darkroom equipment.

The index was compiled by Drusilla Calvert.